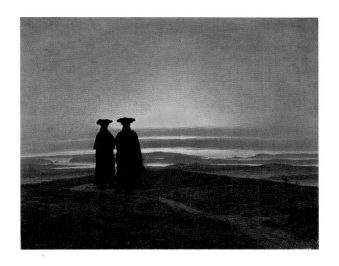

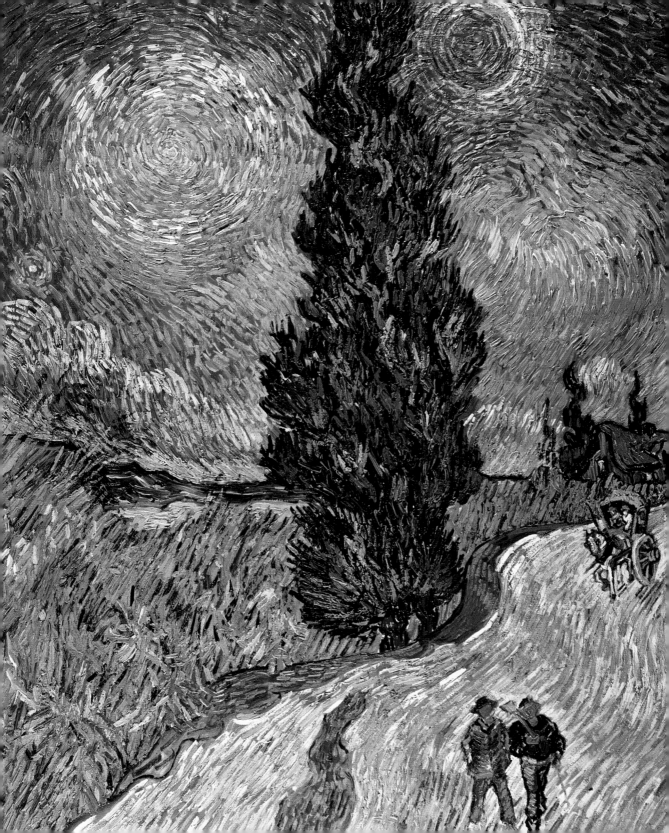

Landscape painting

NORBERT WOLF

TASCHEN

HONG KONG KÖLN LONDON LOS ANGELES MADRID PARIS TOKYO

contents

views of Nature and visions of the world

"The landscape disturbs me in my thinking. It is beautiful, and therefore demands attention." Do Franz Kafka's admissions reduce artists' depictions of nature to mere sense impressions that are opposed to reason, to thinking, as something "entirely other"?

The fresh greens of a meadow, mixed of various hues by John Constable or the Impressionists with an eye to heightening the intensity of a visual impression (ill. pp. 59, 67), to making perception and painting one. A spacious sky overcast with clouds (ill. p. 9), and the eerie half-light that suffuses a stormy landscape. Mountains phantomlike in a distant haze, man present as a tiny figure, a wanderer lost on the seashore (ill. p. 7). Or even the landscapes known as universal (ill. p. 17), whose bird's-eye view reveals a plethora of details, whose horizon expands to continental proportions, which present every imaginable natural feature to the eye: forests, fields and meadows, wildernesses and cultivated land, where mighty mountain ranges and ocean bays in the background draw us into dreamlike distances – all of these things seem hardly to address our intellect, but appeal instead to our emotions as they invite us on visual explorations through pictures.

There can be no doubt that landscape painting replies to a historical development in sense and sensibilities, and hence to a history of perception. But not only to this. Landscape, as a subject of art, by no means disturbs our thought processes. Rather, it triggers them, even if our thoughts take the form of resistance to its superficial charms. In most cases, landscape proves to be a projection screen with a great symbolic depth of focus. Many artistic landscapes are no longer, or not solely, naturalistic mirror images of the colorful natural realm. In a fascinating way, landscape painting has to do with human images of the world at certain times and places, which in turn reflect cultural idiosyncracies. Consequently, it would be inappropriate to lump together Chinese, Japanese, Korean landscape paintings with Western ones, simply because they all share the common theme of "nature." This is why the following discussion of the genre will be limited solely to the history of landscape painting in Europe and America.

In his book *Miniatura,* written in about 1650, the English painter Edward Norgate stated that it was not until the Renaissance that landscape was liberated from its subordinate role of mere background to religious or mythological scenes. As an example, we might take the right-hand panel of a small triptych, attributed to Dieric Bouts and dating to about the middle of the fifteenth century. Here, the figure of St. Christopher is surrounded, at those points where earlier a gilded

1331 — A document confirms that, at the behest of the City of Siena, Simone Martini undertook excursions to inspect sites which would figure in his city hall frescoes

1. CASPAR DAVID FRIEDRICH

<u>The Monk by the Sea</u>
1808–1810, oil on canvas,
110 x 171.5 cm
Berlin, Staatliche Museen zu Berlin –
Stiftung Preussischer Kulturbesitz,
Gemäldegalerie

1

ground would have appeared, by a landscape in evening light (ill. p. 17). Landscape, Norgate went on, was emancipated from its role of auxiliary to become an independent art form in its own right. Autonomous landscape painting was a discovery of the modern age.

Landscape as an Aesthetic Phenomenon

The history of the concept appears to confirm this view. While in the medieval period the word "landscape" designated politically and legally defined areas, and eventually smaller, cohesive natural spots, in the early sixteenth century it took on a technical and aesthetic meaning and entered the vocabulary of art. In a famous diary entry of 1521, Albrecht Dürer (1471–1528) described the Dutchman Joachim Patinir (ill. p. 33) as a "good landscape painter." At about the same time in Italy, the apparently innovative genre came to be known as *paesaggio*. Giorgione's (1477/78–1510) *Tempesta* (ill. p. 11), for instance, was described by a Venetian connoisseur as "a small landscape, on canvas, with a storm, a gypsy woman, and a soldier." Whatever the painting may actually depict – its iconography remains a bone of con-

tention to this day – in the eyes of the artist's contemporaries, it belonged in the new category of landscape painting.

Prior to the early sixteenth century, in other words, no evidence can be found that "landscape" was used in an aesthetic sense, with reference to painting and art. However, practical experience generally tends to precede concepts. Landscape painting, too, existed long before people found a name for it. So what does this name stand for? In what cases and from what date is it proper to speak of landscape painting?

Does Bouts's *St. Christopher* represent a landscape with an accessory figure or a figure in a landscape setting? Is a landscape picture automatically equal to any representation containing a range of natural features? If so, such pictures would always have existed, and the discussion of time limits would be superfluous. In that case, the rock formations assembled like a puzzle and the stylized trees in front of a gilded ground in an altar panel painted in about 1350 by the Master of Hohenfurth (ill. p. 11) would have to be classified as a landscape. Yet this would be to use the term in an inflationary way that would deprive it of all meaning. The art historian Max J. Friedländer defined landscape in 1947 as follows: "Land is the surface of the earth or a

1336 — Petrarch reportedly climbs Mont Ventoux. His description of the view from the peak is considered one of the earliest
aesthetic descriptions of landscape

2

part of that surface. Landscape, on the other hand, is the face of the land, the land in its effect on us."

Although people who are confronted existentially by nature — farmers, shepherds, hunters — are familiar with the topographical features of a region and its typical flora and fauna, they generally do not experience these aesthetically. Only people who are not vitally involved in nature, who see it from a certain distance, "transform" it subjectively into landscape. "Landscape," according to recent ways of thinking, is constituted first and foremost in individual perception. People to whom nature appears in the form of landscape no longer live unthinkingly in nature. They are alienated from it, and can feel one with nature only through the mediation of aesthetics. In 1767, the French philosopher Denis Diderot (1713–1784) said that landscape paintings were hung on the walls of salons by city dwellers in order to compensate for their loss of contact with nature. Landscape, as scholars now generally agree, represents a nature that, on the one hand, has passed through the filter of ideas, values or norms, and on the other, is based on modern subjectivity.

A "lesser" genre?

Paradoxically, this very subjectivity was the main reason why academic opinion in the modern age, far down into the nineteenth century, sabotaged landscape painting. Already at the period when a theoretical interest in landscape first began to grow, in the Italian Renaissance, the official judgements were not always favorable. Leon Battista Alberti (1404–1472), for instance, relegated the subject in frescoes and panel paintings to the lower tiers. "Landscapes, trees, water, fishermen and harbors that represent trade," Alberti declared, "entertain people because they are low, and because they are beneath the earnestness of public life… Labor for the purpose of survival can be depicted only with the amused smile of the comic, charming or grotesque."

As the visual arts grew increasingly confident of their ability to compete with most noble human sciences, genres like landscape, which seemed to require less intellect, were relegated to the second or third rank. Like Alberti, almost all Italian art experts from the Quattrocento onwards believed that man was the measure of all things, and that by comparison to history painting, landscape played no more than

1444 — Konrad Witz paints what may have been the first exact topographical landscape in art history
1494 — Dürer's first landscape watercolors, a milestone in the history of the genre

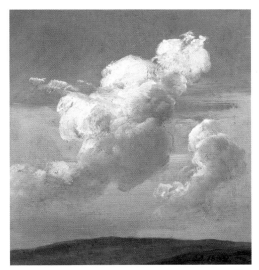

3 4

a subordinate role – explaining why they liked to refer to it, based on ancient Greco-Roman art theory, as a *parergon,* or accessory.

In his *Osservatzioni della Pittura* (Observations on Painting), published in Venice in 1580, Cristoforo Sorte was just as unshakeably convinced of the reason-based superiority of Italian art over that of other nations as the sixteenth-century writer Francisco de Hollanda. De Hollanda averred that the great master Michelangelo (1475–1564) denigrated Netherlandish painting for its false piety (explaining its appeal to women, "especially very old and very young ones," as well as to clergymen and noblemen, "who lack a sense of true harmony") as well as for its superficial trompe-l'œil, or deception of the eye. The Lowlands artists were said to paint "green fields, shady trees, rivers, bridges, and what they call 'landscapes,' and also many vitally active figures, scattered here and there. And although all of this may appeal to certain eyes, in truth it lacks real art, true measure, and right relationship, as well as selection and clear arrangement in space…"

Paolo Pino, in his *Dialogo della pittura,* published in Venice in 1548, explained such preferences in terms of national character: "The northern peoples *oltramontani* are very gifted in the way of rendering great distances visible, and this thanks to the fact that they depict the countries they inhabit and their own wild and wooded nature. But we, the Italians, live in a cultivated garden, whose charm is conveyed more by its sight than by its imitation." Here the contrast between cultivated, civilized nature and wilderness is geographically defined. The Netherlandish scholar and biographer of artists, Lampsonius, then proceeded to turn the tables, flattering Titian (c. 1485–1576) in a letter of 1567, "…Your Excellency has earned more fame by far than all of our Netherlanders in landscape painting, in which subject we believed to have won the field, while in the figurative, too, we were vanquished by you Italians."

In the seventeenth century, academies established themselves throughout Europe as arbiters of taste. When Dutch painters left Italian Renaissance ideals behind in favor of particular sense impressions, leading to an increasing differentiation of landscape subjects, such as the seascape or marine, the academic art pontiffs disqualified such pictures as insignificant, because they "merely" pleased the eye and provided little to occupy the mind.

A case in point was Carel van Mander's *Schilder-Boeck* of 1604. The author was forced to admit that landscape painting had gained the rank of an independent discipline. Yet he immediately ap-

1504 — Publication in Venice of Jacopo Sannazaro's bucolic novel "Arcadia," which would have immense effects on the pastoral landscape

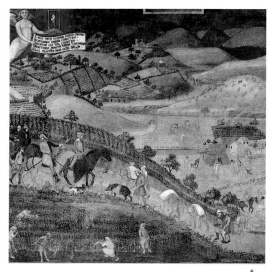

5. AMBROGIO LORENZETTI

Country Life, from "The Consequences of Good Government"
c. 1337–1340, fresco (detail)
Siena, Palazzo Publico, Sala dei Nove

6. GIORGIONE

The Tempest (La Tempesta)
1507/08 oil on canvas, 83 x 73 cm
Venice, Galleria dell'Academia

7. MASTER OF HOHENFURTH

Christ on the Mount of Olives, from the Hohenfurth Altarpiece
c. 1350, tempera on canvas on wood, 100 x 92 cm
Prague, Národni Galeri

5

pealed to the idealistic art theory of the Italian Renaissance and demanded that artists erect an opulent edifice of ideally composed views on the unavoidable foundation of natural motifs. Among art genres, van Mander accorded first place to histories – mythological, biblical and allegorical figurative paintings – and complained that his countrymen currently favored pure imitation of nature, which he considered an error in artistic conception.

This rejection was entirely canonized in the classical academic art doctrine of seventeenth-century France. *Nature ordinaire,* or ordinary nature, it declared, even when rendered with the greatest fidelity, could never do justice to the highest demands and standards of art. This logically led to a ranking of subject matter which, in André Félibien's *Conférences de l'Académie Royale de Peinture et de Sculpture pendant l'année 1667* (Paris, 1669), led to binding guidelines for the following period. Only still lifes of fruit and flowers ranked lower in the hierarchy than landscapes; above them came animals and human figures, and at the very top, history paintings. Despite the fact that objections to this ranking grew ever more frequent in the eighteenth and nineteenth centuries, the criteria for good art continued to be defined by academic value judgements. Towards the end of the eighteenth

century, a period when landscape painting and especially the landscape watercolor (ill. p. 11) became a determining factor on the English scene, the first director of the London Academy of Art, Joshua Reynolds (1723–1792), persisted in according this genre a low status. At best, the heights of history painting could be approached only by an "ideal" landscape composed on the basis of regular measure.

The same opinion was reflected in the classical art doctrine of Germany at that period. "In Claude Lorrain, nature declares herself eternal" – this statement of Goethe's, set like a monument to one of the greatest landscape painters in art history (ill. p. 51), might sound on first hearing like an unconditional recognition of landscape painting. Yet this was not Goethe's intention at all. What he meant was that with Claude, landscape had reached the highest level it was capable of achieving within its limits – the full glory of art, in the academic sense, was still reserved for the ideal composition with figures, which surpassed all mere naturalism.

In the course of the nineteenth century the influence of the academies increasingly waned, and as a result, landscape came in for a re-evaluation. Many a thinker of German Romanticism ranked the "sheer phenomenon" in painting, "the art of appearances," higher than

1518 — In a contract between Hans Herbst and a Basel monastery, mention is made of a "landscape" to be painted by the artist

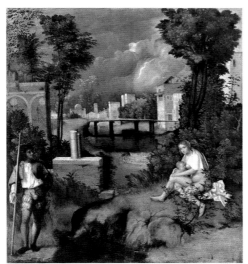

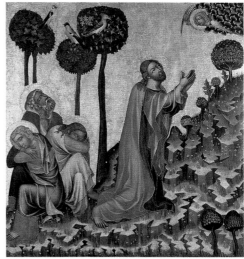

6 7

literary content and, like the Schlegel brothers, accorded priority to the genre with the "most uninteresting" subjects – landscape painting.

"The abstractions are perishing, everything is airier and lighter than what went before, everyone is flocking to landscape, seeking something determinate in this indeterminacy…" stated the Romantic painter Philipp Otto Runge (1777–1810) in clear opposition to Goethean classicism, then went on to ask whether the very highest peak in art might not be achieved in this very field. And the English author, painter and social philosopher John Ruskin (1819–1900), in a work written between 1843 and 1856, originally entitled *Turner and the Ancients* but published as *Modern Painters,* attempted to prove that the future belonged to the landscape and that in this field, the contemporary age outshone all previous periods.

Official evaluations of the field admittedly represented only one side of the coin. On the other side, the immense and growing public popularity of landscape pictures over the centuries gradually undermined academic dogma. Even in Italy, the cradle of the official denigration of landscape, many voices were raised from the fifteenth century onwards to confirm the widespread presence in diverse collections of landscapes, or at least pictures with landscape back-

grounds. Around the middle of the Quattrocento, Bartholomaeus Facius described works by Jan van Eyck, Rogier van der Weyden, and Pisanello which could be admired at the Court of Naples, including, he wrote, a tornado, a world or country map, and a view of a distant landscape. In 1535, Federico Gonzaga of Mantua purchased a full one hundred and twenty Netherlandish paintings, among them, as a contemporary reported, twenty "burning landscapes," by which he apparently meant depictions of natural disasters, or hellfire scenes à la Hieronymus Bosch. In 1568, Giorgio Vasari wrote that a German landscape could even be found in every shoemaker's shop in Italy.

A time curve in collectors' passion for landscapes comparable to that in Italy was seen in the Netherlands as well. While there, not a single dated landscape painting, and very few signed ones, have survived from the sixteenth century's first three decades – likely an indication of the low status of the field – the late 1630s saw a remarkable landscape boom, resulting not least from the rise of Antwerp to the richest trading city in the Netherlands and one of Europe's most important shipping centers. There, numerous workshops specializing in landscapes created a demand to match, and vice versa, they reacted to a potential clientele that extended far beyond the country's borders.

1521 — Albrecht Dürer describes Joachim Patinir as a landscape painter, introducing the term into art history
1521 — "Paese," or landscapes, are mentioned in the inventories of Marcantonio Michiel of Venice

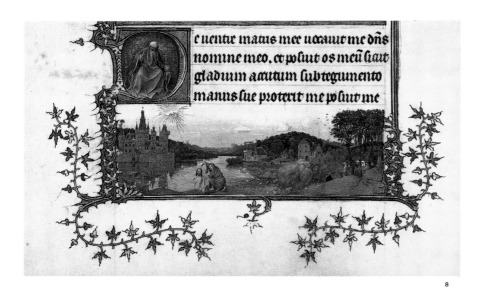

8

ᴛʜe ᴇarly success story of a ɢenre

According to written sources, ancient Greek painting included natural scenes used as picture backgrounds. No examples of this practice have come down to us. Very early on, the philosopher Plato (428/27–348/47 BC) wrote in his treatise *Kritias* that "The painters… represent earth, mountains, rivers, forests, the sky, and everything around them…" The mere listing of these ingredients, however, does not prove that the binding context of "landscape" based on subjective perception, as defined above, already existed at that point in time. The considerably later "Odyssey landscapes" of Roman antiquity (ill. p. 9), whose Greek forerunners likely date to around 150 BC, likewise probably tended to represent more a sum of natural details than being based on a comprehensive painterly vision.

In ancient theory of the kind recorded especially by the Roman architect Vitruvius, landscape figured as a mere foil with no value of its own. It had its place as garden house wall decoration where it served solely a superficial, popular, even shallow, entertainment purpose.

Early and high medieval art, too, included landscape elements in paintings and reliefs as no more than ciphers for certain places in open nature or as symbolic signs, without resorting to landscape depictions based on any innovative aesthetic sensibility. Nowhere did aesthetic purposes, for their own sake, replace the metaphysical message of the works. Even though the descriptions of nature in medieval poetry and epics, or in the travel letters of the day, certainly reflected a vivid receptiveness to nature, the majority of Romanesque and Gothic depictions of nature still rested on ancient patterns, such as the *locus amoenus,* or paradisal natural location. Such clichés, in which centuries-long traditions were reflected, say nothing or very little about a personal susceptibility to the charms of nature or landscape, if it existed at all at that period.

According to recent insights, the beginnings of true landscape art lay in the Italian Trecento, where it emerged earlier than in the rest of Europe thanks to certain social and philosophical preconditions.

Many factors contributed to the emergence of a modern "landscape aesthetic." In the first third of the fourteenth century, for instance, the municipal administration of Siena had the walls of the great council hall in the Palazzo Pubblico decorated with frescoes depicting several castles recently taken by the commune, having previously sent the painter, Simone Martini (c. 1284–1344), to the actual

1548 — In a dialogue about painting ("Dialogo della pittura") published in Venice, Paolo Pino explains national preferences in landscape painting in terms of national character

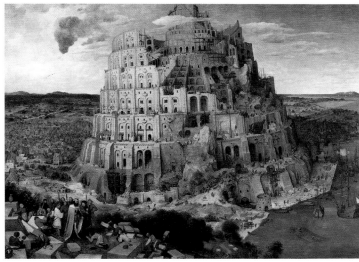

8. JAN VAN EYCK
The Baptism of Christ in the Jordan, fol. 93v
of the "Turin-Milan Book of Hours" (detail)
c. 1420/25, tempera on parchment,
28.4 x 20.3 cm
Turin, Museo Civico d'Arte Antica,
inv. no. 47

9. PIETER BRUEGEL THE ELDER
The Tower of Babel
1563, oil on wood, 114 x 155 cm
Vienna, Kunsthistorisches Museum Wien

sites to make topographical studies. In 1338, they commissioned Ambrogio Lorenzetti (c. 1290–1348) to paint the monumental fresco *The Consequences of Good Government* (ill. p. 10) in the adjacent hall. The entire project was an exercise in communal self-advertising. The city fathers wanted a depiction of the actual, visual facts. This prompted Lorenzetti in particular to create a new type of landscape panorama, very likely the first modern landscape picture in art history. From the same period we also hear of definitely subjective confrontations with nature, translated into unprecedented descriptions of landscape impressions.

Francesco Petrarca (1304–1374) was a celebrated Italian humanist active at the papal court in Avignon from 1326 to 1353. A poet and scholar known throughout Europe, Petrarch set out in 1336 on what was then a quite unheard-of enterprise – climbing a mountain. He ascended Mont Ventoux in southern France, with St. Augustine's autobiographical *Confessions* in his knapsack. This according to a letter Petrarch says he addressed directly after his climb, on April 26, 1336, to the Augustinian pater Francesco Dionigi de' Roberti.

This letter describes Petrarch's adventure in terms both graphic and suffused with ethical and religious maxims. He evokes his experience at the summit of Mont Ventoux, the enormous panorama of the Provençal countryside that unfolds around him, in words so eloquent that one is tempted to see in them a revolutionary, aesthetic landscape experience, a new and subjective sensibility for an open countryside extending to the far horizon. For a long time, Petrarch immerses himself in the view, only to be abruptly torn from his *voluptas oculorum,* or lust of the eye. He had inadvertently opened the *Confessions* at the following passage: "And people go to marvel at the peaks of mountains and the immense waters of the sea and the far-flowing rivers and the fringe of the ocean and the orbits of the stars, and pay no attention to themselves." Contrarily, Petrarch turned away from his admiration of natural beauties and, as he put it, turned his inward eye upon himself.

Yet the obvious parallel he drew between his rejection of the world on Mont Ventoux and St. Augustine's conversion, triggered doubts as to the authenticity of Petrarch's ascent. Many began to view this passage in his letter as an allegory of the course of human life. Petrarch's letter may in fact have not been written until about 1353–54 and purposely predated to 1336, the thirty-second year of his life – the same age at which St. Augustine experienced his conversion.

1580 — In Venice, Cristoforo Sorte publishes his tract "Osservazione della Pittura," the first systematic treatment of landscape painting

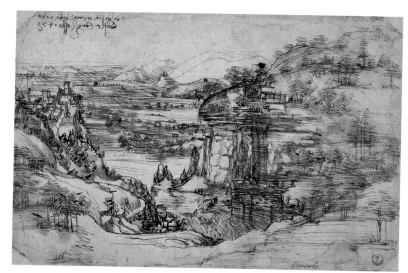

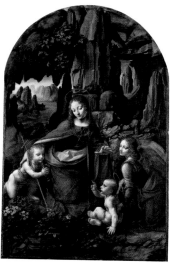

10

11

Whether or not this interpretation is correct, it changes nothing about the incredible visual curiosity and aesthetic pleasure reflected in the poet's description of nature. What a difference there is, for instance, between Petrarch and King Peter III of Aragon, who in the late thirteenth century ascended Mont Canigou and wasted not a thought on the lovely view, merely reporting that he was hissed at by a terrifying dragon on the Pyrenean peak.

In his Florentine chronicle, Giovanni Villani reported on a partial solar eclipse seen in Tuscany on July 7, 1339. A certain Taddeus de Florentia had ruined his eyesight gazing at the phenomenon. A monk chided the man for having succumbed to the "lust of the eye" rather than turning his spiritual eye to the sun of eternal justice. He had tried to perceive useless things with his eyes instead of occupying himself with things that would benefit his life to come. This harsh criticism proves that "visual lust," or aesthetic pleasure in nature, although not the rule back then, was likely a temptation nonetheless. And Trecento painting reacted to this temptation with an ardent interest in astronomical phenomena. It is enough to recall Giotto's (1267–1337) fresco *Adoration of the Magi* in the Arena Chapel at Padua, in which the Star of Bethlehem is depicted in the form of a comet.

At the start of the fifteenth century, dominance in the "landscape" genre began to pass to Old Netherlandish art. Its backgrounds and views through a window presented natural scenes in highly precise detail yet with a wonderfully atmospheric texture of color and light and a convincing effect of depth despite deviations from correct perspective. These impressively rendered landscape grounds were "exported" throughout Europe, and fed back into the Italian Renaissance, of which the Netherlanders in turn had cognizance without adopting its transformation of the picture into an "illusionary window" based on mathematical perspective.

At a very early point in time, the miniatures of the Limbourg Brothers (ill. pp. 26, 27) and book illustrations by the brilliant Jan van Eyck (c. 1390–1441) marked the revolutionary onset of this process. Van Eyck was the author of the illustration on folio 93v of the so-called *Turin-Milan Book of Hours* (ill. p. 12). Depicted at the lower margin of the sheet is the Baptism of Christ, a pioneering depiction whose new, strikingly atmospheric view of nature would hardly be matched in the coming decades. We see a landscape at evening, as the shadows of twilight fall, with the baptism scene tiny in the foreground. The water shimmers bluish with silvery reflections; the horizon

1609 — After the cease-fire with Spain, the northern provinces of the Netherlands assume leadership in the country's art and bring landscape to a culmination

10. LEONARDO DA VINCI

Arno Landscape, 5 Aug. 1473
1473, pen and ink, 19,5 x 28.5 cm
Florence, Galleria degli Uffizi,
Gabinetto dei Disegni e delle Stampe

11. LEONARDO DA VINCI

The Madonna of the Rocks
1495–1499 and 1506–1508, oil on wood,
189.5 x 120 cm
London, The National Gallery

12. KONRAD WITZ

St. Peter's Miraculous Fishing of Souls
1444, tempera on wood, 132 x 154 cm
Geneva, Musée d'Art et d'Histoire

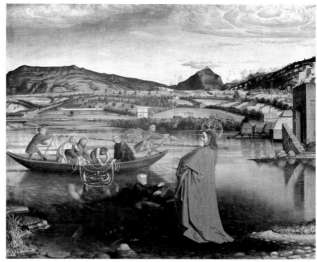

12

is low; the sky and distant mountains appear blurred in the hazy atmosphere. A castle is reflected in the water, as small figures, adapted to the natural surroundings, approach between two hills. In the initial "D", God the Father is enthroned, sending the Dove of the Holy Spirit to earth in a sheaf of rays.

Book illustration indeed served as a field of experimentation especially in the landscape genre, thanks largely to its exclusive reception by individual, generally highly educated connoisseurs of art. Already in the early 1340s, a Parisian miniature on the subject of *The Mysterious Garden,* in a manuscript of works by the poet and musician Guillaume de Machaut, focused on a clearing in the woods in front of a castle, with animals but not a single human figure – an ambience that begins to show definite traits of autonomous landscape painting. Soon panel painting began to adopt the innovations developed in book miniatures, and provided a contribution of its own that was likewise marked by pioneering inventions.

In 1444 Konrad Witz (c. 1400–1445/46) painted the panel *St. Peter's Miraculous Fishing of Souls* (ill. p. 15). It was originally the left wing of an altarpiece commissioned for the Cathedral of St. Pierre in Geneva. Depicted from normal viewing height, the landscape space no

longer depends on the figures' actions but provides the precondition for them. The figures, now standing firmly in the landscape, take on physical weight and plasticity. The natural surroundings are treated as a uniform phenomenon in terms of both space and color. Witz shifts the biblical story to Lake Geneva with the Alps in the background. This is very likely the first topographical landscape executed north of the Alps, suffused with precise observation of nature. For the first time, an artist represented the fact that water is shallower near the shore of a lake and grows deeper towards the center, as the stones at the foreground edge of the picture indicate.

Opinions are divided whether a famous drawing by Leonardo da Vinci (1452–1519) from 1473 (ill. p. 14) likewise represents an identifiable area, a view of the Arno Valley near Florence, and whether it can be considered an incunabulum of direct observation of nature – or is merely an imaginary view and studio product. What is certain, is that Albrecht Dürer's earliest landscape watercolors (ill. p. 8), from his first trip to Venice, were executed in situ. No artist before Dürer had handled watercolor with such freedom and sureness. It would almost seem that he consciously focused on the fleeting impression, immersed himself in the transitory beauty of the moment. Yet despite the enthusiasm we

**1635 — In reaction to plagarisms, Claude Lorrain, one of the greatest landscapists of all time,
begins his "Liber Veritatis," a record of his paintings**

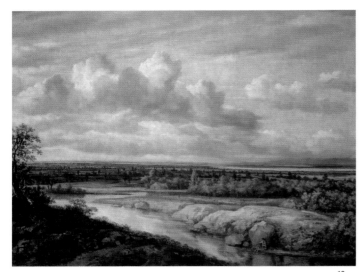

13. PHILIPS KONINCK

<u>Flat Landscape</u>
c. 1653/55, oil on canvas, 133.3 x 165.7 cm
Munich, Bayerische Staatsgemäldesammlungen,
Alte Pinakothek

14. JAN BRUEGHEL (BREUGHEL) THE ELDER

<u>Great Fish Market</u>
1603, oil on wood, 58.5 x 91.5 cm
Munich, Bayerische Staatsgemäldesammlungen,
Alte Pinakothek

15. DIERIC BOUTS (?)

<u>St. Christopher, right-hand panel (interior)</u>
<u>of the triptych "Pearl of Brabant"</u>
1450s, oil on wood, 62.6 x 27.5 cm
Munich, Bayerische Staatsgemäldesammlungen,
Alte Pinakothek

13

as modern viewers feel in face of these watercolors, we must not forget that although they reflect a fresh view of nature, they were not, or not always, intended as ends in themselves but as preparations for background landscapes in finished paintings.

At the start of the sixteenth century, finally, a branch of landscape painting came to the fore in Germany which, as in Albrecht Altdorfer's (c. 1480–1538) *Danube Landscape with Wörth Castle near Regensburg* (likely a false topographical identification; ill. p. 4), further emancipated the subject and – in parallel to the symbolically charged "world or universal landscape" – raised it to a more or less independent theme. Altdorfer belonged to what is known as the "Danube School," whose paintings and prints feature especially luxuriant landscape backgrounds or autonomous landscape depictions. These not seldom have an expressive content that verges on the pantheistic. The same attitude was revealed by the German humanist Konrad Celtis, who in an ode of around 1500, "To Sepulus, the Superstitious," admitted that he would rather worship God in nature than in the painted rooms of churches.

In many Protestant regions of Germany, and especially in Reformational sections of the Netherlands, this attitude led in the sixteenth century to the removal of sacred imagery from churches and its destruction, and the increasing restriction of art to secular subjects. In Geneva, John Calvin (1509–1564) banned all religious imagery as idolatrous, but permitted secular history paintings, depictions of animals, and landscapes. Edward Norgate, as mentioned, devoted several pages in his book *Miniatura,* c. 1650, to landscape painting. This, as he indicatively stated, was "the most innocent of all forms of painting, which even the Devil himself surely could not accuse of idolatry."

Landscape between Renaissance and Baroque

In Renaissance Italy, landscape flourished in Venice especially. At the onset of the Cinquecento, for instance, Giorgione transformed the ambience of his figure scenes, mysterious and suffused with esoteric ideas, into a "poesy" of nature – to use the then current term (ill. p. 11). Together with him, Venetian poets and painters such as Titian (ill. p. 31) and Lorenzo Lotto (c. 1480–1556) infused fresh life into the pastoral, a genre that had come down from antiquity in written sources. These were scenes of rustic life, shepherds and dairymaids

1729 — Albrecht von Haller's didactic poem, "The Alps," provides crucial impulses for landscape painting
1757 — Publication of "A Philosophical Enquiry into the Origins of Our Ideas of the Sublime and Beautiful,"

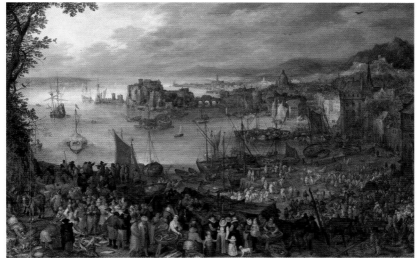
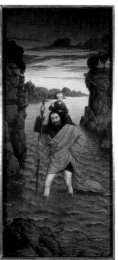

14 15

sporting in an Arcadian, i.e. paradisal nature, which were perceived as landscapes charged with a compelling atmosphere. Towards the close of the sixteenth century, foreign painters in Italy – foremost among them Adam Elsheimer (ill. p. 45) – and Italians such as Annibale Carracci (1560–1609) took up traditions of this kind, and, with their aid, established what became known as the "ideal landscape" (ill. p. 18). This trend continued with modifications into the seventeenth century, and reached its brilliant zenith in the "classical" or "heroic" landscapes of two Frenchmen living in Rome, Nicolas Poussin (1594–1665) and Claude Lorrain.

With the Flemish artist Paul Bril (c. 1554–1626), the Netherlands likewise markedly influenced the development of idealized Roman landscape painting in the seventeenth century. Yet their crucial contribution to the history of the genre was to take a different direction, leading to a liberation of landscape that gave it the status of a subject in its own right.

This change can be illustrated by comparing two paintings by Jan Brueghel (Breughel) the Elder (1568–1625). In *Great Fish Market,* 1603 (ill. p. 17), a particolored crowd populates the rise in the foreground and the strip of shore between a bay and the imposing buildings of an imaginary harbor city. The rocky island recalls the Castel dell'Ovo and Naples, where Jan had stayed during an Italian journey. The natural scene dissolves into an evocative expanse at the horizon. The high vantage point (which becomes a true bird's-eye view only with respect to the background), the endless horizon, which draws the eye into ever-farther distances, the abundance and variety of figures and objects both natural and man-made – all of these features possess the qualities and meet the criteria of a universal landscape. It is this confrontation of the near and familiar with aspects of a yearned-for, heightened strangeness that lends the painting, for all its realistic traits, its characteristic dreamlike atmosphere. Desired worlds infuse their charm into banal, everyday life, and are the destination of the ships departing from the harbor.

In Jan's painting *The Garden of Eden,* before 1612 (ill. p. 20), the viewer is no longer master of an all-encompassing vision. The ground-level vantage point entails a different form of visual exploration: that of a close-up, encyclopedic view. The religious theme of Eden – the miniscule Fall from Grace at the left – merely serves as an alibi for a combination of motifs determined by scientific curiosity. Visual proximity and a sharp-focus miniature style go hand in hand

by the English philosopher Edmund Burke, which would profoundly affect Romantic landscape painting
 1781 — In England, Thomas Gainsborough develops his "Exhibition Box" to display his "transparencies," nature scenes painted on glass

16

with empirical objectivity, a naturalistic marshalling of visual data. To ensure that these details remain in harmony with the great whole of nature, a covert reference is added in the right background. Where the river of Eden flows out into the world, echoes of a universal landscape reverberate. Otherwise, Jan's Eden feels like a local, earthbound place, objectively seen and deriving its effect of the miraculous from exotic fauna and flora. It was no coincidence that this period witnessed the discovery of far-flung continents (ill. p. 49), and the arrival in Europe, and especially in the Netherlands, of an unprecedented variety of animal and plant species. This imported abundance was both an intellectual and aesthetic stimulus to all who witnessed it.

Yet soon the appeal of real-world landscapes would no longer depend on exotic or iconographic ingredients to generate high-tension.

Sixteenth-century Flemish landscapes, despite their symbolic motivation and fantastic embellishments, already reflected an empirical interest in topography. In the early seventeenth century this tendency to realistic representation of nature rapidly grew stronger. Now, however, the lead was taken by artists in the northern, Protestant Netherlands, that is, in Holland. Following the cease-fire with Spain in 1609, Holland developed into a political, economic and cultural great power in Europe. Altered property relationships required an official registration of real estate, particularly in and around the large cities. This, together with the northern provinces' newly achieved political independence, stimulated a new sense of patriotic pride. Not surprisingly, this led to new methods of visual "surveying" in landscape painting as well. A key factor in this regard was a close cooperation of Dutch landscapists with cartographers.

An extensive group of landscapes – from the hand, for instance, of Jan van Goyen (1596–1656), Jacob van Ruisdael (ill. pp. 52, 53), Salomon van Ruysdael (1600/03–1670), and Philips Koninck (1619–1688; ill. p. 16) – which are generally referred to as panoramas – in fact had their roots in cartographic projection methods. As the seventeenth century progressed, the horizon grew lower and lower, first letting more sky into the picture, then stupendous cloud formations and lighting effects. The extraordinary dimensions of some of Koninck's works, the largest Dutch landscape paintings in existence, rival wall maps in size. The artist attempted to give the Dutch regions he depicted the look of elements of a larger view of the world. By giving the horizon a gentle curve, he let the universe penetrate into the image of a particular section of his homeland.

1785/86 — The English landscapist Alexander Cozens publishes his influential "A New Method of Assisting the Invention in Drawing Original Compositions of the Landscape"

16. ANNIBALE CARRACCI

<u>Roman River Landscape with Castle and Bridge</u>
c. 1595/1600, oil on canvas,
73 x 143 cm
Berlin, Staatliche Museen zu Berlin –
Stiftung Preussischer Kulturbesitz,
Gemäldegalerie

17. PETER PAUL RUBENS

<u>Autumn Landscape with Steen Castle</u>
c. 1636, oil on wood,
131.2 x 229.2 cm
London, The National Gallery,
Sir George Beaumont Gift

17

In parallel with the singular high points of Netherlandish landscape art, the paintings and prints of Peter Paul Rubens (1577–1640; ill. p. 19), and even more, those of Rembrandt (ill. p. 47), every conceivable facet of landscape was explored by specialists. These included rivers with ferryboats (as in Salomon van Ruysdael), mountains (Esaias van de Velde, 1587-1630; Hercules Seghers, 1589/90–1633/38); coastlines and dunes (Jan van Goyen), and the environs of windmills (Jacob van Ruisdael, see ill. p. 53). Besides motifs from the local environment, scenes from foreign lands appealed to the curiosity of Dutch audiences. Frans Post (c. 1612–1680) depicted landscape scenes from Brazil (ill. p. 49), and Allaert van Everdingen (1621–1675) painted Scandinavian waterfalls and rugged mountains, pictures that already conveyed a sense of what would become known in the eighteenth century as "the sublime."

The sublime and the Romantic Landscape

The art of the eighteenth century was marked by decisive changes in the experience of distant and exotic realms, which pro-foundly shaped the definition of landscape painting. These changes related first of all to the classical land of European yearning, Italy. For about two centuries, well-placed young gentlemen had traveled to Italy in order to round off their knowledge of classical antiquity and Renaissance art. In the course of the eighteenth century, this educational motive was increasingly supplemented by a desire to cultivate moods, feelings, and sensibilities – in a word, to enjoy the beauties of the Italian landscape. Many travelers, especially wealthy Englishmen, took watercolorists along to record what they had seen.

The English philosopher Edmund Burke (1729–1797), in his 1757 treatise *A Philosophical Enquiry into the Origins of Our Ideas of the Sublime and Beautiful,* paved the way for an aesthetic of pleasurable chills and sublime thrills. From this point on in Western thought, the categories of grandeur, subjective emotional stimuli, indeed shock effects that illuminated the depths and abysses of the human soul, came increasingly to be viewed as the principal motives behind truly overwhelming works of art.

At about the same time as Burke's treatise, the concept of the picturesque advanced to become a key term of the epoch. Like "Romanesque" landscapes à la Lorrain, Poussin, and Salvator Rosa

1796/98 — Uvedale Price's important tract, "An Essay on the Picturesque, as Compared with the Sublime and the Beautiful; and on the Use of Studying Pictures for the Purpose of Improving Real Landscape," appears in London

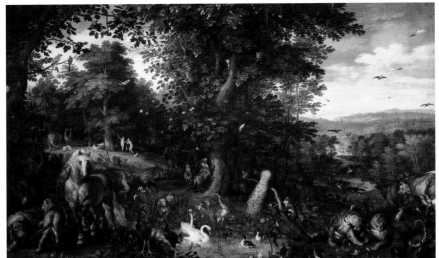

18

(1615–1673), picturesqueness implied an emphasis on feelings and states of mind triggered by certain subject matter, but also by certain methods of rendering.

In the wake of Burke and the magic word "sublime," the focus turned increasingly to regions characterized by painterly qualities and the capacity to induce pleasurable thrills. While the Swiss Alps, the source par excellence of such emotional stimuli, had been depicted as early as the 1760s by William Pars (1742–1782; ill. p. 22), Lord Byron (1788–1824) additionally raised the Rhine and Venice to incarnations of Romantic scenery, and soon streams of tourists were following in the English poet's footsteps.

In the eighteenth century, when men like the French philosophers Jean-Jacques Rousseau (1712–1778) and Denis Diderot (1713–1784), and the German poet Friedrich Schiller (1759–1805), lamented the alienation of man from nature, the subjective, atmospheric, unsullied quality of landscape began to seem a highly desirable value. For it was landscape in particular which Burke saw as a stage for the sublime. Accordingly, interest grew in wild, untamed nature, the Scottish high moors or the mountain chains of the Alps – or dramatic scenery that had witnessed horrors and disasters. Even before the

publication of Burke's book, the French artist Claude-Joseph Vernet (1714–1789) had painted storms at sea and shipwrecks in this spirit (ill. p. 23). Philippe Jacques de Loutherbourg of Strasbourg (1740–1812) proceeded from themes à la Vernet until finally, in England, he began to transpose such sensational effects to depictions of industrial landscapes (ill. p. 21). In the following period, German and English Romanticism from 1800 onwards, but also Europe-wide late Romanticism and American Romanticism in the nineteenth century (The Hudson River School), categorically raised landscape to the prime, and often enough symbolically charged, subject (ill. pp. 64, 65).

Hidden symbolism

In view of the increasingly subjective trend in the landscape aesthetic outlined above, the question naturally arises whether this went hand in hand with increasing secularization, a one-sided concentration on worldly affairs and the viewer's concerns. As a review of the history of landscape painting indicates, just the opposite was the case. Many landscape depictions derived their semantic and formal tension

1801 — In a supplementary volume to Samuel Johnson's "Dictionary," George Mason recommends designing a landscape garden to resemble a landscape painting

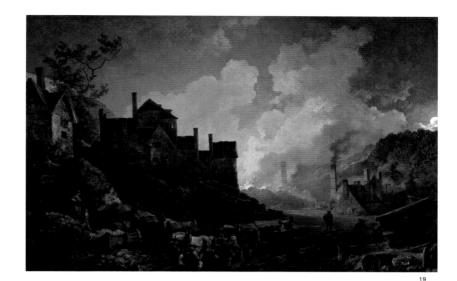

**18. JAN BRUEGHEL (BREUGHEL)
THE ELDER**

<u>The Garden of Eden</u>
before 1612, oil on wood, 59.4 x 95.6 cm
Rome, Galleria Doria Pamphilj

**19. PHILIPPE JACQUES
DE LOUTHERBOURG**

<u>Coalbrookdale by Night</u>
1801, oil on canvas, 67.9 x 106.7 cm
London, Science Museum

19

from a reciprocal relationship between modern visualization and traditional metaphysical content. As Werner Hofmann noted, "Like every secular genre in European painting, landscape emerged from the context of religious themes… It is not… a matter of appropriating landscape for the Christian image of the world, and even less of finding quantitative evidence that the genealogy of every theme in autonomous landscape painting can be traced back to the abundance of natural events and landscape motifs described in the Old and New Testaments. What is more important is that landscape, in its symbolic references, its metaphorical permeability – in short, its aspects of content, is beholding to these very beginnings in religious history painting. If landscape depictions since the fifteenth century trigger a differentiated range of subjective feelings… this is due to the fact that the dramatic stations of the Christian plan of redemption… are reflected in natural occurrences…"

In the following analyses of pictures, we will attempt to show the key function played by "universal landscapes" and their various transformations in the immense relationship of tension between a meaning-forming basis in metaphysical views of the world and subjective "world views."

Yet there are other types and forms of landscape picture that possess a profound symbolic or metaphysical content that far surpasses the mere phenomenon of natural scenery. A few examples from the virtually infinite variety of possibilities may suffice as evidence.

The bizarre rock formations surrounding the Virgin Mary with the Christ Child, the boy St. John, and an angel, which gave Leonardo da Vinci's *Madonna of the Rocks* its modern-day title (ill. p. 14), can very likely be interpreted in terms of Marian metaphor. Already in the Old Testament, in the Song of Solomon (2:14), Mary is described as a "dove in the rocky cleft" and "stone cavern." In addition, the Virgin was viewed as a stone uncleaved by human hands *(lapis sine manu caesus)* and "the lofty, untouched, crystalline mountain and the cave in the mountain" (in Italian, *montagna eccelsa, intatta, cristallina, cavità nella montagna).*

In our next example, Pieter Bruegel the Elder's *Tower of Babel*, a painting from the year 1563 (ill. p. 13), the gigantic tower built around the core of a rocky massif rises in the midst of a landscape under a clear blue sky depicted in a bird's-eye view. To the left, beside a medieval Gothic city, it forms the panorama of a limitless plain extending to a range of hills on the high horizon; to the right, on the har-

**1810 — Heinrich von Kleist publishes his famous review of C.D. Friedrich's "Monk by the Sea" in
"Berliner Abendblätter"**

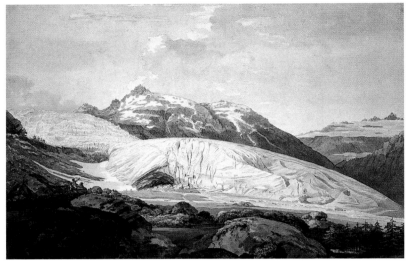

20. WILLIAM PARS
<u>The Rhone Glacier and the Source of the Rhone</u>
c. 1770/71, watercolor and ink, 33 x 48.4 cm
London, The Trustees of the British Museum

21. CLAUDE-JOSEPH VERNET
<u>Nocturnal Snowstorm</u>
1752, oil on canvas, 72.7 x 98.4 cm
Private collection

20

bor side, the expanse of the ocean is evoked. On a rise to the left, a few kneeling stonemasons pay honors to the King of Babylon, to whom they have been introduced by the master builder. In front of the surrounding, antlike swarm of figures and dwellings and the sweeping horizontals of the terrain, the tower, seemingly growing organically from the ground and tapering upwards in a series of concentric rings, appears all the more colossal, especially as its vertical axis coincides with the central axis of the picture.

Bruegel lends his image aspects of an alternative world by suffusing the natural harmony of a universal landscape with the dissonance of human strivings for godlike power. This hybris is reflected in the transition from plain, rustical Romanesque architectural elements on the lower facade to increasingly refined details in the upper tiers of the tower, which, according to the Book of Genesis, was intended to reach heaven. As this sequence of styles suggests, the construction project has lasted for many generations, and its ambitious time plan reflects a vain attempt to rival the immortality attributed to nature. The landscape itself, meant to stand for the world as a whole, appears to encourage this universal attitude, and man's godlike view of nature to generate a technology that overestimates its own power. The Tower of

Babel rises on a coast, at the edge of an ocean harbor teeming with ships. Although seafaring also sometimes figured as a symbol of human hybris in contemporaneous visual and written sources, many voices from the Middle Ages onwards emphasized the useful aspects of this activity. According to them, seafaring already began with Noah's Ark, though it did not really get properly underway until the building of the Tower of Babel.

The ensuing confusion of tongues and dispersal of tribes supposedly provided a reason to turn to shipbuilding as a way to reach distant lands and islands. Especially after the discovery of America and during the period of exploration – the decades in which the painting was done – this aspect took on new relevance, because people believed that with the American natives, they had rediscovered one of the biblical tribes who had set off for new shores after the Babylonian project proved futile.

Tacitly yet clearly, the great aesthetic and semantic charm possessed by Bruegel's painting despite its moral message reflects the temptation which "world pictures" would exert from this point on. They provided an overview of a world instrumentalized by human strivings – and the self-intoxication to which this led.

1816 — In an address on the inauguration of the New York Academy of Fine Arts, DeWitt Clinton declares the American landscape, due to its unsullied character, to be more sublime than any European natural scene

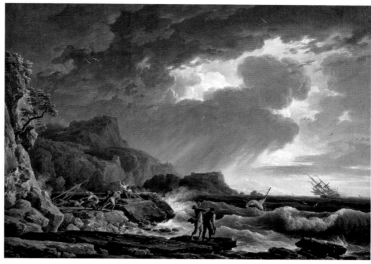

"...Ground is to the landscape painter what the naked human body is to the historical. The growth of vegetation, the action of water, and even of clouds upon it and around it, are so far subject and subordinate to its forms, as the folds of the dress and the fall of the hair are to the modulation of the animal anatomy. Nor is this anatomy always so concealed, but in all sublime compositions, whether of nature or art, it must be seen in its naked purity. The laws of the organisation of the earth are distinct and fixed..."

John Ruskin

21

Even the sober panoramas of a Philips Koninck (ill. p. 16) might contain tacit symbolic religious content under their apparently so straightforward, secular surface. Experts have referred to the emblem books that were so popular in the seventeenth century. An emblem created by the poet Jan Luyken bears the motto *Het verschiet*. This word can mean "horizon," but also "perspective" – in the sense of a vanishing point, or, in a religious connotation, the future. Under the illustration to the motto stand the well-known psalm verses: "Lord, teach me that it must come to an end with me. Verily, my days are but a hand's breadth for you, and my life is as nothing in your eyes." From all this, the art historian Henk van Os concludes, hypothetically but convincingly, "Possibly Koninck's landscapes with their strikingly low horizon, like Luyken's emblem, allude to the life perspective of man..."

Landscapes on the Path to Modernism

"Recall of the Mythical" is the rubric under which the Swiss art historian Oskar Bätschmann discusses the School of Barbizon. Camille Corot (1796–1875), to choose one member at random, occa-sionally populated his airily painted, undramatic natural scenes, which can be viewed as an overture to Impressionism, with mythological ac-cessories (which Impressionism abandoned entirely), thus evoking the Arcadian unity of human figure and nature (ill. p. 67). In Bätschmann's view, these were mythologically enriched alternative images to touris-tic landscape attractions, sights to which people gave no more than a fleeting glance – as well as an alternative to the terrain of commer-cially exploited and debased nature. This type of landscape admittedly remained marginal in the art of the nineteenth century; only Arnold Böcklin (1827–1901) continued to focus on this mode (ill. p. 71).

The "earthly paradise," symbolized in landscape – where but in Impressionism does this paradigm seem to have found such convinc-ing form? After all, landscape is viewed as the principal theme of this direction in art. Still, as has recently been emphasized, Impressionism also dealt with urban motifs – promenades, boulevards, parks, populat-ed by fashionably dressed people – filtered through the vibrating light typical of the style, evoked by means of a "divisionistic" breaking down of color into individual dabs and strokes. To understand Impressionistic landscape, it is better to start with the city and imagine it extending into the periphery. Here, landscape amounts to the city dweller's recre-

1835 — German physician and naturalist Carl Gustav Carus publishes his "Briefe über die Landschaftsmalerei" (Letters on Landscape Painting)
1840 ff — Introduction of Cook's Tours, marking the inception of organized mass tourism

23

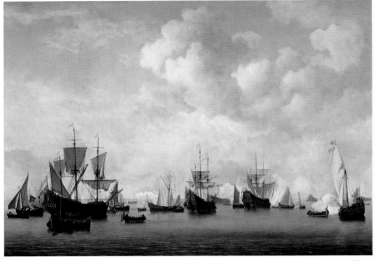

22. WILLEM VAN DE VELDE THE YOUNGER
The Netherlands Fleet in the Straits off Guinea
1664, oil on canvas, 96.5 x 97.8 cm
Madrid, Museo Thyssen-Bornemisza

23. EDVARD MUNCH
Winternacht (Winter Night)
c. 1900, oil on canvas, 120 x 180 cm
Zurich, Kunsthaus

22

ation area, an excursion destination in the precincts of the modern metropolis. As Jutta Held writes, "Smoking factory chimneys on the horizon, a train steaming through the countryside, the modern railway bridge by Argenteuil, which Monet repeatedly painted, belonged to the holiday spots in the vicinity of Paris. It was not until the 1880s that Monet began to avoid the tourist crowds and depict remote points on the coast, the cliffs of Etretat and the solitary house of the coastguard at Pourville, where not a human soul is to be seen. The search for unsullied nature began once more, and would be continued by the next generation's painters, in the South of France and in the colonies."

Wherever they painted, it is generally agreed that the Impressionists liberated landscape from the centuries-long realm of the metaphysical and emptied it of symbolic and speculative references. This is not to say that their landscapes were devoid of meaning. On the one hand, they left hidebound academic practice behind to open the door to new experiences, giving a view of nature that was no longer bound by existing rules and forms. Instead, they focused on the momentary and transitory aspect of perception, and with the resulting, form-dissolving paint application, they brought into play the first abstractions, which subsequent artists would develop – admittedly abandoning the

mimetic tendencies to which the Impressionists still adhered. By capturing basically evanescent momentary effects in paint – concurrently with the earliest photographs – these artists stylized fleeting light reflections into permanent ones, and lent a refined split-second impression of the outside world a claim to lastingness. This entailed a certain shallowness of thought in the pictures. Émile Zola diagnosed this in his 1886 novel *L'Œuvre,* where he described a painter who "refined sensation to the point of finally extinguishing the intellect." In the context of an ever more banal everyday life, modern society surrounded its search for identity and meaning with the beautiful illusion of landscape.

Based on then current theories of color, the Impressionists divided the paint substance into small units, creating a scintillating matrix of color aimed at giving form to evanescent appearances, and increasingly emancipating color from the objects depicted. The Post-Impressionists, or Pointillists, ramified this process of color division still further, in the knowledge that the tiny color particles, in accordance with the principle of complementarity, would blend into a unity in the viewer's eye. The network of colored dots served as a sign system by way of which the relationship of man to the outside world was couched in terms of an optical discourse.

1880 — The German musician Ernst Rudorff becomes one of the most vehement critics of mass tourism, accusing it of destroying landscapes
1891 — Paul Gauguin undertakes his first journey to the South Seas; four years later, he would leave Paris

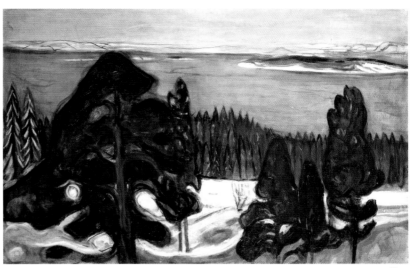

23

Paul Cézanne (1839–1906) began at this point (ill. p. 79) and immediately went a crucial step farther, making him appear, to some critics, to mark the end of "traditional" Western art history, and to others, the inception of modernism, i.e. Cubism, and the path to abstraction. The intuitive image of nature was abandoned in favor of visual data, which are first and foremost color data. Form is the result of color. The perception of nature always implies an observation of the viewer's own perception; visual image and nature stand in a reciprocally structuring relationship.

In Cézanne's eyes, change and permanance did not exclude one another, but were equal partners in image formation, the synthesis of the visual facts. He once expressed this in his famous dictum about art being a harmony in parallel with nature. Then he went on to say, "The landscape reflects on itself, humanizes itself, thinks itself inside me. I objectify and fix it on my canvas… Maybe I'm talking nonsense, but it seems to me as if I am the subjective consciousness of this landscape, and my canvas its objective consciousness."

When Cézanne painted one and the same motif, Montagne Sainte-Victoire, in over sixty works, this was no longer a cyclical process in the traditional sense. Rather than a sequence determined

(among other things) by content, the series served as a field for creative experimentation in building that harmony in parallel with nature Cézanne strived for. Of course this did not imply a complete abandonment of the ideal; instead the artistic image received, so to speak, its own natural law. In the wake of Cézanne, a radical liberation of artistic means, a focus on the painted image as a purely artificial problem, would become a central concern of modern art. The erstwhile "world of landscapes" would be increasingly supplanted by a world of self-questioning immanent to art itself. A telling example of this development is the process of abstraction that took place between two paintings by Piet Mondrian (1872–1944), *Woods near Oele,* 1908, and *Trees in Blossom,* 1912 (both The Hague, Haags Gemeentemuseum).

Although a preference for landscape reached a new apex in Fauvism and Expressionism, in the further course of the twentieth and beginning twenty-first century, theoretical thought largely ceased to deal with the field. Current issues in art revolve around concepts other than those of genre or field. Yet because landscape was likely the genre which stood closest to pure painting in its concentration on color and light, not even a modernity concerned with the autonomy of painting could ever entirely abandon it.

for good, on a search for harmony between man and nature
c. 1900 — In Germany, the "Homeland Protection Movement" laments the loss of the country's natural landscapes

The Month of February, fol. 2v of "Très Riches Heures," Duc de Berry collection

Tempera on parchment, 29.4 x 21.5 cm (sheet), 14.4 x 13.6 cm (image)
Chantilly, Musée Condé, ms. 65

The *Très Riches Heures,* a manuscript in the Duc de Berry's collection described after his death as "an especially rich book of hours," is one of the most renowned codexes in the world. The duke commissioned this devotional volume from the Limbourg Brothers. In the course of the year 1416, however, before the masterpiece could be finished, not only the three artists but their patron died. Subsequently further miniatures were added, until about 1485. The pages today most admired, the depictions of the twelve months in the calendar section, date to the initial phase of illumination.

The arch spanning the rectangular calendar pictures, painted in exquisite lapis-lazuli blue, contains four concentric arched fields. The outermost of these (in the finished depictions) bear the Latin names of the signs of the zodiac that succeed one another in the month concerned. The second field shows the starry band of the zodiac on a blue ground. In the innermost semicircle, finally, the sun god Phoebus is enthroned in his chariot, pulled by winged horses through the sky as he holds the sun in his hands.

Beneath this cosmological coronation and cyclical frame of reference, seasonal activities are depicted in full-page images of courtly or rural genre scenes playing out in front of magnificent background landscapes. In most of these, one of the famous castles belonging to the Duc de Berry or the French crown appears, minutely depicted yet vague, like a mirage. These were bastions and symbols of regency, on a par with the rulers' abundant treasuries and art collections.

In the scene illustrating the month of February, the snow-covered land lies beneath a leaden sky. Life is in the grips of cold. Outside, wood is being cut and hauled away; inside, women and a man warm themselves at an open fire. All three unashamedly lift their garments, the couple in the back so far as to reveal their genitals. How the noble patron must have chuckled at such indiscretion!

The duke will also have enjoyed what was then a new type of landscape aesthetic. The eye roams from detail to detail, from the smoke rising from the house into an iron-gray sky to the frosty breath of the man in the courtyard, from the random patches of snow on the haystack to the sheep huddled in the fold. Birds peck at grain just scattered by a peasant, whose footprints are still visible in the snow.

Never before had such things been painted, and much time would pass before anything comparable appeared – in Pieter Bruegel the Elder's *Hunters in the Snow* (ill. p. 39). This, the earliest true winter picture in art history, possesses an unsurpassed precision of observation and overwhelming beauty recalling that of the brilliant art of the Limbourgs, which is symptomatic of the power of innovation in terms of genre found in late-medieval book illumination.

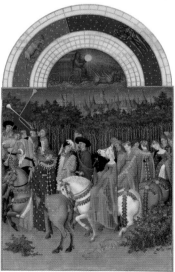

The Month of May, fol. 5v of "Très Riches Heures," c. 1410–1416

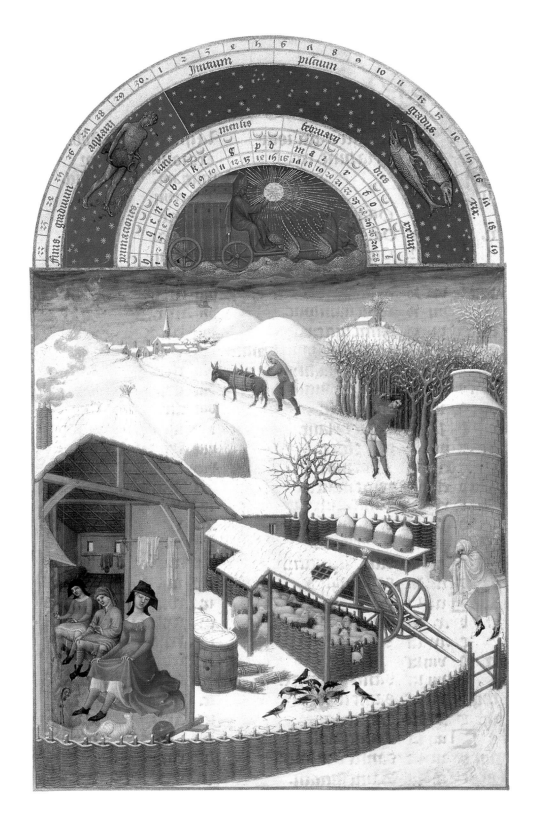

Paradise (left panel of the triptych "Garden of Earthly Delights," interior)

Oil on wood, 220 x 97 cm
Madrid, Museo Nacional del Prado

b. c.1450 in s'Hertogenbosch
d. 1516 in s'Hertogenbosch

The painted interior of the left panel forms the overture to a cosmic panorama that extends over the display side of this fascinating altarpiece. Yet in a closed position, the sonorous basic chord of the retable is set by the monochrome universal landscape illustrated on p. 34. When the wings are opened, that vision of the transparent spheres vanishes, replaced in part by brilliantly hued scenery, in part by a nocturnal landscape lit by flickering fires. Our eye roves restlessly from the creation of Adam and Eve, to a phantasmagorical group of naked figures (copulating, involved in an orgiastic dance, captured in glass cylinders like alchemist's retorts or in outsized fruit), all the way to Hell itself. Riddle upon riddle confronts us. Perhaps most straightforward is the depiction of *Paradise*. The landscape stage extending into immeasurable distances proves to be merely a setting for the expected, traditional biblical scene in the foreground, the green Eden where God brings together men's first ancestors, Adam and Eve – the woman to the man, "that they should become a couple."

Yet the tree of knowledge, through whose foliage a few of the portentous apples shine, is largely concealed by a botanically exotic growth: a dragon-tree, a more than unusual symbol of eternal life in the context of Christian iconography. Bosch illustrates the only apparently peaceful coexistence of animals in the Garden of Eden by a congeries of actually existing creatures – giraffe, elephant, hares, ducks, etc. These have been joined by a unicorn (in whose existence many people in the late Middle Ages still believed), but especially by a legendary fauna of monsters and hybrids not found in any serious text-

book. As a second glance reveals, not all is sweetness and light in God's zoo. Eat or be eaten determines the "ecology" of these unpeaceful, primal beginnings.

The rife imagination of this strange painter runs just as free in these animal, or rather zoomorphic creatures as in the bizarre formations on the horizon (which one hesitates to call "rocks") and in those vegetable shapes, petrified into something resembling architecture, which make up the spring of Eden at the center. Was this blend of natural observation and imaginative form a reaction on Bosch's part to travel descriptions from exotic lands beyond the seas? Or did he simply intend to visualize the unlimited range of potential forms inscribed by God at the beginning of Creation? This question remains open to this day.

In a book on landscape painting, it would be more relevant to inquire into the role played by Bosch in the development of the genre. His role, it is safe to say, went far beyond the fact that he contributed exciting features to the genre of the "fantastic landscape." Though usually only confined to the background, Bosch's landscapes are characterized by an innovative, highly impulsive brushwork and palette, based on a primer layer much thinner than that used by his Netherlandish contemporaries, which makes many details in the panoramas shine out as if flooded by light.

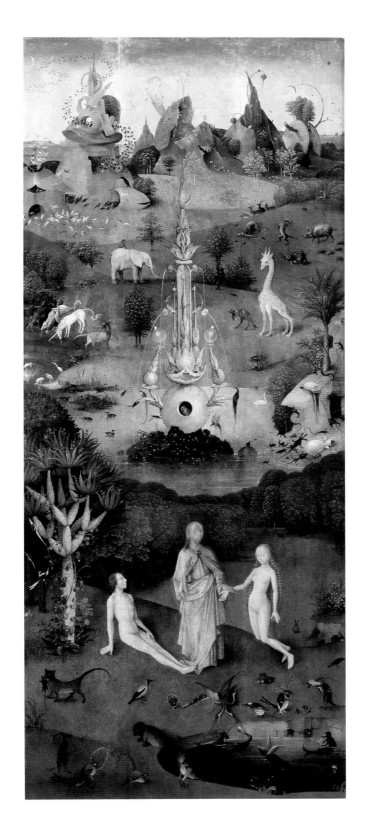

country concert (concert champêtre)

Oil on canvas, 110 x 138 cm
Paris, Musée National du Louvre

b. c. 1490 in Pieve di Cadore
d. 1576 in Venice

Debates on the attribution of *Concert champêtre* fill volumes. And this not only in the wake of Édouard Manet's 1863 paraphrase of this pastoral landscape, *Le Déjeuner sur l'herbe,* with its scandal-rousing nude women accompanied by two fully dressed men (Paris, Musée d'Orsay). The original attribution of the painting to Giorgione began to be questioned in 1839, and gradually the name Titian came into play. The compromise solution, that Titian merely made corrections, is currently finding less and less support. Likewise insecure are many details of the iconography. On the stretch of lawn in the foreground, the nude female figure standing by a well at the left has a counterpart in the seated nude with flute on the right. Between them is a young nobleman clad in Venetian velvet costume and holding a lute, accompanied by a shepherd. Another shepherd with his flock is visible further back, on the right. Do the women represent muses or nymphs? Is the one drawing water from the well – or pouring it in, and listening to the sound it makes?

What is certain is the artist's intention to heighten the landscape to a place in which all yearnings for paradise converge. Rich color and serene harmony, the calm of a strict formal order, and masterful picture-plane division express existence in its ideal and captivatingly aesthetic form. In such a scene, human beings and mythical figures in complete harmony of body and soul stand for life outside the cities, in its ideal, natural determination and poetic content. All of this was also reflected in the humanistic music theory of Venice, which began to appreciate musicians as creative artists equal to poets and painters.

One of the literary sources for *Country Concert* has been identified as Jacopo Sannazaro's pastoral novel *Arcadia,* in which the Grecian shepherds' land sung by ancient authors was extolled as a landscape of the spirit. After Giovanni Boccaccio had reintroduced Arcadia into literature in his *Ninfale d'Ameto* in 1340, Sannazaro's novel, written in about 1480 and published in Venice in 1504, stylized the Greek pastoral into a transcendental landscape, bathed in the golden yet melancholy glow of a distant haze, by associating the beauty of the Venetian "terra ferma" with the ancient motif.

The line of succession of *Country Concert* leads directly to two Arcadian pictures of the seventeenth century, by Nicolas Poussin. The shepherd's paradise, which came into fashion once again with Honoré d'Urfé's pastoral novel *L'Astrée,* of 1607, continued as a masquerade dream of Eden in French Rococo painting, and found a sequel as late as the early twentieth century in Paul Cézanne's nudes in a paradisically beautiful nature.

> **"And the flutes of the shepherds in the blossoming valleys come to the ear perhaps more sonorously than the pure and worthy flutes of the musicians in the opulent rooms. And who would doubt that a spring which, encompassed by green plants, emerges from the solid rock, appeals more to the human spirit than all of those other fountains, works of art, which are fashioned of the whitest marble and are resplendent with much gold?"**
>
> Jacopo Sannazaro, "Arcadia," proem

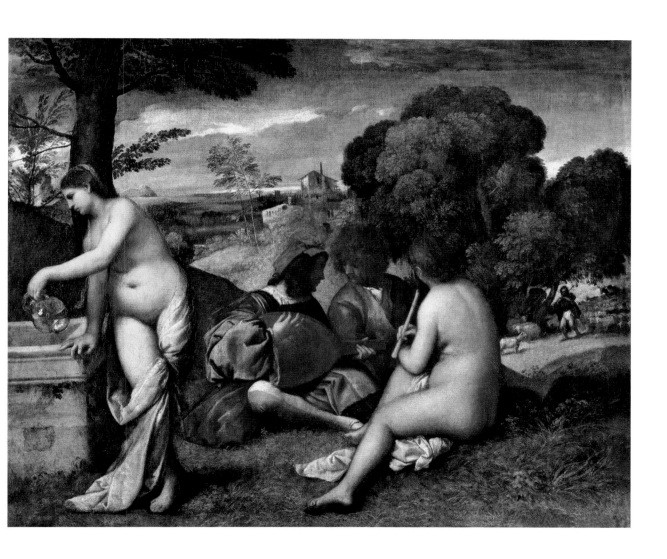

Landscape with St. Jerome

Oil on wood, 74 x 91 cm
Madrid, Museo Nacional del Prado

**b. c.1480 in Dinant or Bouvignes-
sur-Meuse
d. 1524 in Antwerp**

The Netherlander Joachim Patinir is viewed as the inventor, or at least principal initator, of the "universal landscape." His paintings enjoyed wide renown throughout Europe in the early sixteenth century, and Albrecht Dürer praised him highly as a landscape artist. Patinir painted and signed his *Landscape with St. Jerome* in about 1515. From a high vantage point, the eye is initially drawn to the foreground motifs, but then passes on stage by stage through an immense landscape, a spatial continuum that extends to the far horizon and narrow strip of sky. In the left foreground, in front of a soaring rock formation with a cavity that attracts the gaze, the saint is seated in front of a primitive shelter built up against the rock. He is concentrating on extracting a thorn from a lion's paw. In the distance, barely detectable, Patinir has depicted further legendary events in which the lion, St. Jerome's companion, plays a role. Finally, on the rocky plateau with monastery building, St. Jerome forgives and blesses the repentant merchants who had stolen a donkey from him.

Protected by the dark brown rugged rock, the saint turns his back on the wide landscape, which extends infinitely to the right and upwards. Lost in thought, he sees nothing of its abundance and beauties.

The narrow, arduous path to the monastery in Patinir's painting represents the steep path to virtue, at whose end the thieving merchants find penitence and forgiveness. Does this imply that the surrounding landscape can be read as synonymous with the temptations of the superficially so attractive and intrinsically so depraved world from which the ascetic turns away, to occupy his humble yet so worthy place on its margins? The historical St. Jerome definitely expressed himself in such terms in a letter written to Paulinus in the late fourth century: "You do well to avoid the cities and their bustle, settle in the country, and seek Christ in solitude. You should pray alone with Christ on the mountain…"

The threatening rock needles at the upper left would seem to corroborate, by contrast, this metaphysical level of meaning. There not only exists the divine mountain frequently mentioned in the religious literature, but its counterpart, the devil's mountain, the place of earthly ensnarements, as St. Augustine wrote as early as the year 400.

With this painting Patinir created a universal landscape, not because he depicted a particolored panorama but because he went beyond the aspect of landscape to expound a view of the world, a comprehensive Christian view. The subjectivity of the visual experience that transforms a depiction of nature into a landscape compels the individual viewer to assume a very personal standpoint with respect to this implied world view.

"(when a painter) wishes to depict stretches of land and deserts… he can shape them. The same holds if he desires valleys or strives to descry broad reaches of land from mountain tops, and wishes to observe the sea beyond them on the far horizon, it is in his power to do so, and the same holds when he wants to look upwards from the deep valleys to the high mountains or from high mountains down into deep valleys and the coast. In general, whatever… exists in the world or in our imagination, he possesses first in his mind and then in his hands…"
Leonardo da Vinci

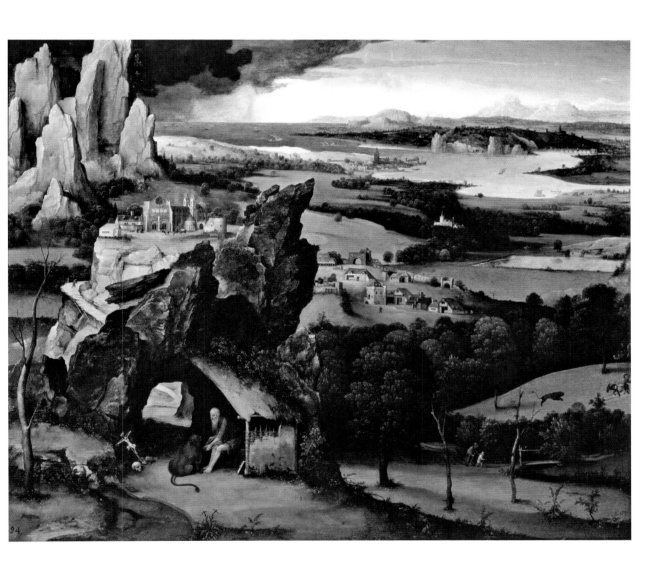

тhe вattle of аlexander at іssus

Oil tempera on wood, 158.4 x 120.3 cm
Munich, Bayerische Staatsgemäldesammlungen, Alte Pinakothek

b. c.1480 in Regensburg (?)
d. 1538 in Regensburg

A grisaille (gray-in-gray painting) on the outer wings of a triptych likely painted by Hieronymus Bosch towards the end of the fifteenth century is considered by many authors to be the first universal landscape in art history. In it, we look down from an improbable height on a flat earth encompassed by a transparent crystal sphere. Albrecht Altdorfer of Regensburg has likewise transformed a landscape panorama into a universal landscape fraught with significance. Here the earth appears small by relation to the firmament and its cosmic spendor, and human beings and their works miniscule. The painting originally belonged to a cycle of history paintings done for the duke and duchess of Bavaria.

It depicts the battle of Issus, at which Alexander the Great defeated the Persian King Darius in 333 BC. Slightly cropped at top and sides, the painting's format is humble by relation to its enormous thematic content.

As correct as it may be to characterize Altdorfer's depiction as a battle painting, this amounts to a considerable restriction. The scene is determined to a much greater extent by the grandiose landscape panorama that blends into the sky at the slightly curved horizon. The conglomerate of mountains and seas surpasses all previous German landscapes many times over in terms of breadth and extension. On the right, the sun's rays emerge from a roil of clouds to illuminate the sea. The many light reflections on this, the sunny side, suggest dramatic movement in the clouds, which on the left hang dark and dense in the sky. There, obliquely opposite the sun at the upper left edge, appears the moon, surrounded by an aureole of clouds. At picture center, the clouds part to reveal a celestial space that lies like an aura around the inscription panel, suspended directly above the gap in the battle where Alexander and Darius confront one another.

The view extends from north to south, over the island of Cyprus and into the eastern Mediterranean region. To the right lies the seven-branched Nile delta, and immediately to its left, separated by a narrow isthmus, appears the Red Sea. The visual idea underlying the design of this landscape panorama transmutes the landscape background of an historical depiction into the vision of an immense map seen from a bird's-eye view. Every commentator has noted that Altdorfer's comprehensive ordering of a natural scene was intended to point beyond the actual historical event, drawing an analogy between world history and cosmic occurrences that culminate in the phenomena of solar light and color. The sun, standing in the west, triumphs over the half moon – the very year when Altdorfer painted this universal theme, the Turks were besieging Vienna, Occident and Orient confronting each other once again in a fateful battle.

Hieronymus Bosch, The Creation (?), triptych exterior "The Garden of Earthly Delights," 1480–1490

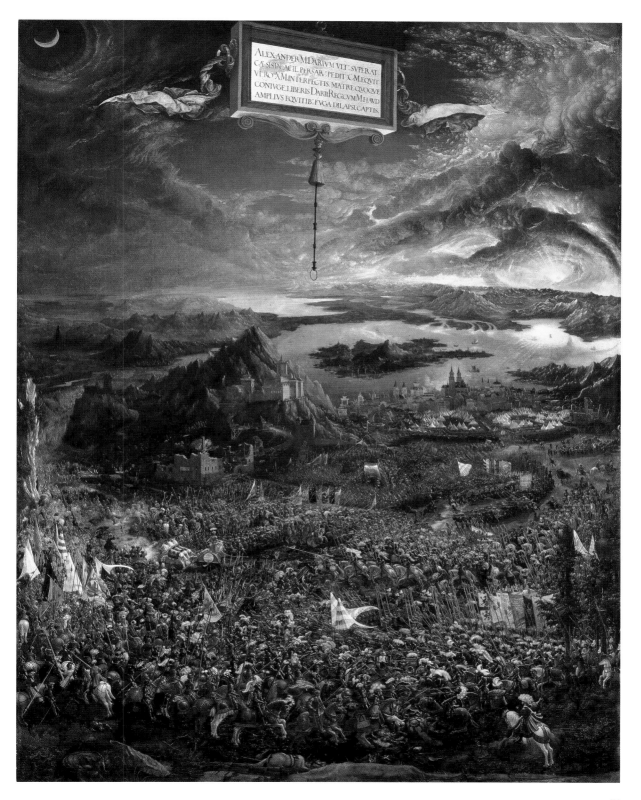

ALEXANDER M DARIVM VLT: SVPERAT.
CÆSIS IN ACIE PERSAR: PEDIT: C M. EQVIT
VERO X M INTERFECTIS. MATRE QVOQVE
CONIVGE. LIBERIS DARII REGVM M. HAVD
AMPLIVS EQVITIB: FVGA DILAPSI.CAPTIS.

Narrow wall of the stanza del cane in villa Barbaro

Fresco (detail), 362 x 355 cm
Maser (near Treviso), Villa Barbaro

b. 1528 in Verona
d. 1588 in Venice

With Titian and Tintoretto, Veronese formed the great triad of Venetian painters in the advanced sixteenth century. With the assistance of his workshop, he decorated the interiors of the villa in Maser designed by Andrea Palladio. The wall opposite the windows, under a religious motif of *The Mystical Betrothal of St. Catherine,* is occupied by an illusionistic landscape view. The flanking trompe-l'oeil architecture includes painted marble statues of two allegorical figures, and beneath the "window" on the landscape sits a little dog, made not of flesh and blood but likewise of eye-deceiving paint.

Garden dreams have long existed not only outside the four walls we occupy but on these walls themselves. In his monumental scholarly work *Naturalis Historia* (Nat. Hist. XXXV/116), completed in 77 AD, Pliny the Elder mentions the painter Spurius Tadius, active in the reign of Augustus, "who was the first to create the most charming murals, country houses and arcades and gardens, copses, pleasure woods, hills, fishponds, canals, rivers, coastlines, and whatever else one could wish, as well as various figures of promenaders or ship passengers and people going by land on donkeys or in carriages to their country houses, as well as fishermen, fowlers, or hunters, not to mention vintners." In about 25 BC, the Roman architect and writer on art Vitruvius, in the seventh volume of his architectural tract *De architectura libri decem,* reports on naturalistic paintings and the fact that artists had begun to decorate the walls of long arcades "with various landscape depictions, whereby they executed these paintings on the basis of quite specific features of the locations. Namely, harbors, foothills, coastlines, rivers, springs, isthmuses, shrines, forests, mountains, cattle herds, shepherds, and other things were represented…"

Leon Battista Alberti in the fifteenth century, and other, later Renaissance artists and theoreticians, were inspired by such passages. In the sixteenth century, Paolo Veronese would put Alberti's notions of landscape painting into practice, by depicting such subjects not on the walls of arcades but in the rooms of Palladian villas. One main intellectual foundation for the frescoed garden and landscape motifs in ancient Roman interiors was surely the Augustan ideal of freedom as described by Virgil, and similar ideas underlay the comparable (no longer extant) creations of the fourteenth century which emerged in the orbit of the poet Petrarch and Italian Neo-Platonism. However, it was not until the sixteenth century that artists turned with fervor to this type of interior decoration.

In the meantime, as alienation from nature proceeded apace, the "dream of nature" had become the opposite pole to urban life. And when this arcadian dream was disturbed by the mundane reality of farming on the Venetian mainland estates, people simply had the longed-for paradisal landscapes painted on the wall, as if seen through a window. One of the most magnificent adaptations of ideal, arcadian landscapes was Veronese's frescoes for Daniele Barbaro, an equally great humanist and feudal lord. This was the source of a tradition that extended down to the pastoral idylls that Marie Antoinette staged in the park of Versailles in the late eighteenth century. The unsullied landscape became a symbol of an agrarian form of life whose supposedly God-given order was enlisted in resistance to every attempt at social change.

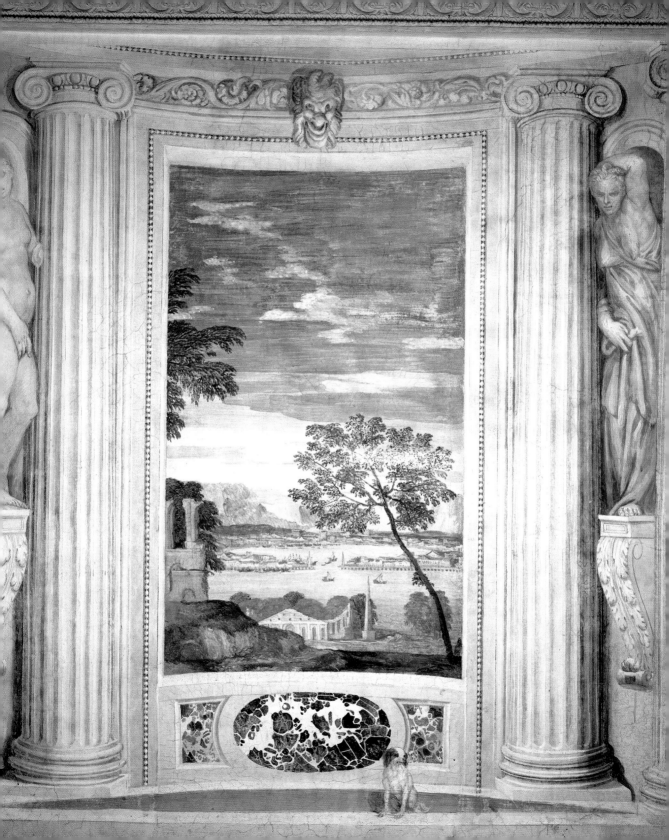

Hunters in the snow

Oil on wood, 117 x 162 cm
Vienna, Kunsthistorisches Museum Wien

b. 1525 / 30 in Breda (?)
d. 1569 in Brussels

In medieval art, the months were represented by human activities and pastimes characteristic of the season. By the time of the renowned calendar pictures of the Duc de Berry's *Très Riches Heures,* such glimpses of nature had already crystallized into atmospheric landscapes (ill. p. 27). This was the tradition on which Bruegel relied in his series of six (or possibly twelve) panels devoted to the changing seasons and peasants' work outdoors, which are generally considered the culmination of his oeuvre. Completed in 1565, the series begins with the pre-spring season *(The Gloomy Day).* As back then the year began in March, this means January or February. As the oppressive atmosphere shows, man had not conquered nature, but rather had to fight for survival in face of its mercilessness. The most famous example of the cycle, however, is the winter picture. Its principal motif is a group of hunters, seen from behind, bringing their catch to a village lying farther down. Their movement leads the eye over the wide winter landscape to the tiny figures sporting on the ice and the snowcapped mountains on the distant horizon. The activity of slaughtering, traditionally representing the winter months, is relegated as a subordinate motif to the courtyard of the inn at the left edge.

Our eye roams from a high vantage point over an extensive, diverse landscape that develops from the cultivated foreground area to an ever wilder nature in the distance. Principal lines direct the eye along a diagonal that begins with the houses on the left, accentuated by a stark row of bare trees, and extends to the lower right, into the valley. Only there, where it runs up against the mountain barrier and takes the opposite, diagonal direction towards the plain extending to the left to the horizon, is a sense of depth created which counters the dominant horizonal of a panorama. The apparent excerpt character of the field of vision has a very modern look. Still, the subjective mood prompted by the atmospheric phenomena of a winter day and the contrast between the habitations in the foreground and the forbidding cold towards the horizon, should not tempt us into reading the picture solely in emotional terms. This would be to isolate the image of winter from its former context in the cycle of seasons.

A cycle of pictures of this kind puts its parts in a meaningful order because it is meaning-generating. In calendar depictions of antiquity and the Middle Ages, the ordered day, the ordered year, and the ordered course of life were embedded in a mythical or Christian cosmology in which each particular occurrence found its place in the context of a metaphysical temporal structure. This also holds for Bruegel. Even though this brilliant artist compellingly "individualizes" the different seasons and charges them with subjective moods, on the whole they remain beholding to a higher principle of order. By means of this synthesis, Bruegel engendered a pictorial unity that evokes the changes in nature in the course of the seasons in an unprecedented way.

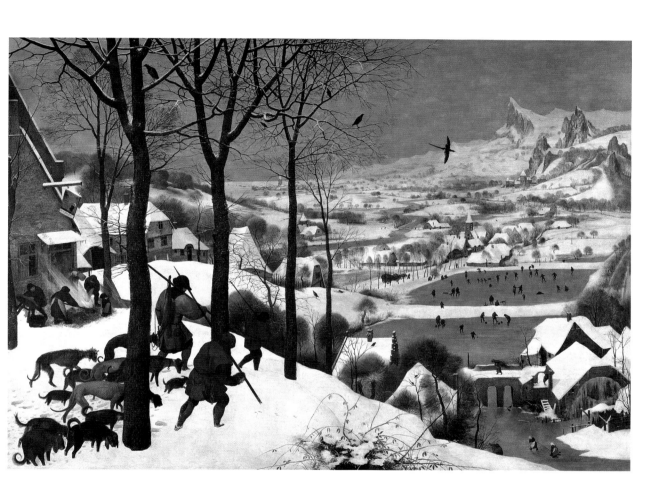

view of toledo (storm over toledo)

Oil on canvas, 121.3 x 108.6 cm
New York, The Metropolitan Museum of Art, H.O. Havemeyer Collection

**b. 1541 in Candia (Heraklion), Crete
d. 1614 in Toledo**

What does it mean to view the field of "landscape" in terms of limited themes such as "urban landscape" and "industrial landscape" (ill. p. 21)? Do such definitions separate landscapes that have been civilized, regimented, even destroyed by progress, from "pure" landscapes? There are uncounted paintings in which the treatment of such subjects is by no means intended pejoratively. These reflect attempts to find aesthetic principles by which a painterly sensibility for natural landscape can be transfered to subjects of this kind, thereby lending them an unexpected appeal or message. The view of a city may suddenly become an atmospheric configuration, a pictorial ensemble perceived through a sensitive mind and eye – not least when the city and its natural surroundings congeal into an organic whole.

This is wonderfully illustrated by a certain famous painting. It was done by a major representative of Mannerism, who was born in Crete, was schooled in the Venetian style in Italy, and arrived at an expressive, spiritualized style in Spain – Doménikos Theotokópoulos, known as El Greco. The painting is his view of the eastern section of Toledo. It shows landscape formations and buildings rising in exaggerated steepness and dominated by the Alcázar, the royal palace. The bell tower of the cathedral, which should actually lie to the far right, indeed outside the picture field, has been shifted to the left by El Greco.

This picture, one of the artist's most renowned, has provoked many controversial interpretations, due especially to the phantasmagorical, threatening character of the city silhouette looming over a livid, hilly landscape. One theory detects the influence of the tradition of the overview landscape as practiced by Dutch and Flemish painters working in Rome around 1570. One might easily come to this opinion in view of the high vantage point with respect to the foreground, and the chain of hills falling off to the left, which assumes the function of a horizon.

Yet still the differences predominate: Due to the exaggerated steepness of its hilly perch, Toledo and its landscape ambience appear forced into a vertical composition that goes far beyond a normal vertical format, which compells the viewer, right after the foreground, to assume a very low vantage point. Obviously the painting represents more than a record of the look of the place, possesses a mood that far transcends the merely atmospheric, and, like most universal landscapes, is very probably suffused with symbolic aspects. Yet unlike universal landscapes, the viewer is not so much given an overview of the scene as spirited directly into its gloomy mood. Rather than directing the eye from a magisterial height over a spacious panorama, this composition leads it irresistibly from bottom to top, from the flamelike trees in the foreground and the conglomerate of hills, over the vertical light reflections on the buildings' contours, and up to the apocalyptic sky. Whatever the intrinsic statement of this landscape may be (the hypothesis has been advanced that it represents a fragment of a crucifixion scene), it pulls the viewer into it and its overwhelming evocativeness.

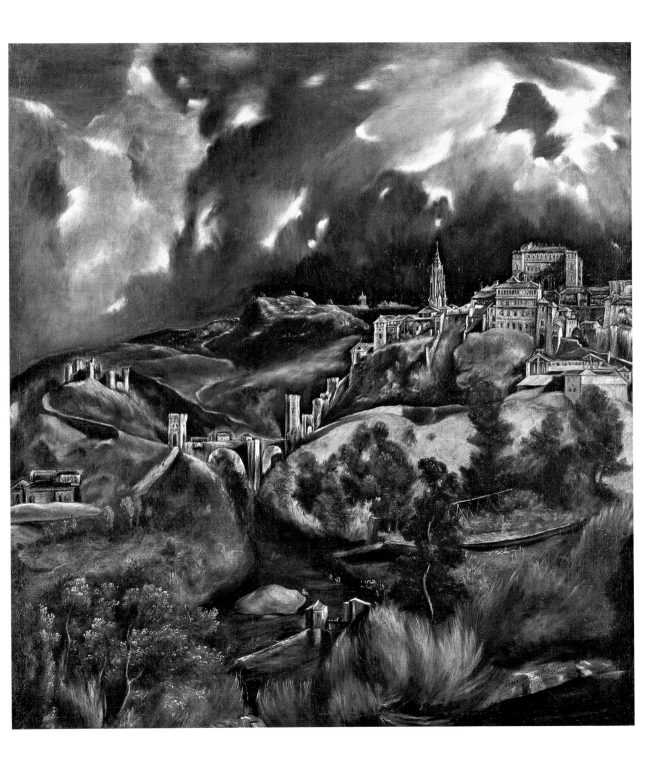

Landscape with grotto

Oil on wood, 61.2 x 93 cm
Bonn, Rheinisches Landesmuseum Bonn

In what was likely the first European book to be devoted solely to the mountains, *De Montium origine* by Valerio Faenzi (1501), a poetic comparison was already made between mountain chains and ocean waves rising crest upon crest. In God's perfect Creation, mountains were said to contribute to *varietas,* variety, and thus to the adornment of the earth. This clearly reflected the emergence of an aesthetic view of the mountain realm, which became even clearer in the writings on art of the Netherlandish painter Carel van Mander. In 1604 van Mander encouraged his colleagues to join him in "… climbing some way up the steep cliffs that are dampened by the scudding clouds with moist lips and their uppermost peaks washed. In general their color is light gray; often their bare horns protrude from the midst of a dense pine forest. Yes, of the cruel rocks full of white pillars that fill Switzerland and divide France from foreign lands (Italy), a few peaks often stand as if over the clouds and below castles."

The new aesthetic appeal which the previously so often "demonized" Alpine region now began to exert on travelers and artists, was

L. v. Valckenborch, Maas Landscape with Mine and Smelting Sheds, 1580

reflected in the paintings of Joos de Momper, among others. The Netherlander may well have undertaken an Italian journey and been deeply impressed by Alpine vistas. His grandiose, sometimes phantasmagorical mountain scenes frequently include a grotto, as does the present painting. While in other artists' work grottoes usually figure as elevated sites of religious pilgrimage, in the Bonn painting the motif becomes the focus of the composition. One of the three accessory figures is characterized as an artist, down on his knees and drawing the rocks in front of him. Although this is not the first appearance in Momper's work of the figure of the artist in the great outdoors, it is indicative that here he deals with the phenomena of the mountain realm. This enthusiasm corresponded with the emergence of Alpinism, represented in the sixteenth century especially by Swiss naturalists and littérateurs.

In addition to Alpine landscapes with sometimes fantastically exaggerated rock formations, the sixteenth century also saw the spread of geomorphically precise landscape depictions. The religious or superstitious interpretations of mountains common in the medieval period waned as interest grew in mineral resources, and concomitantly, in the earth's interior. In this context, the mountains came to be viewed as a treasure trove of useful raw materials, be they subterranean water reservoirs or metal ores. The result was an intensification of scientific research. These developments are wonderfully manifested in a painting by the Flemish artist Lucas van Valckenborch (c. 1535–1597), now in Vienna. Its veristically rendered rocky terrain is crowned by a castle (seat of the gentleman who owned the mining rights), below which, to the foreground, spreads a detailed scene of the Alpine smelting and founding that accompanied the mining of ore deep inside the mountain.

The Flight into Egypt

Oil on copper, 31 x 41 cm
Munich, Bayerische Staatsgemäldesammlungen, Alte Pinakothek

b. 1578 in Frankfurt am Main
d. 1610 in Rome

Adam Elsheimer found his artistic Eldorado in Italy, first in Venice, then in Rome. With his compositions he advanced to become an admired landscapist in the Eternal City. It was what the writer on art Giovanni Baglione described in 1642 as the "miraculous harmony" of Elsheimer's small masterpieces that fascinated viewers, as well as their virtuosic play of light from different sources. *The Flight into Egypt,* small as a miniature, was admired from the start for the charm of its nocturnal mood. After Elsheimer's early death, Rubens tried to acquire the copper plate from his friend's estate, so much did he admire it. Joachim von Sandrart praised the small picture in his *Teutsche Academie* of 1675 as an astonishing masterpiece "the likes of which no one before has ever made, and a work which, both in all parts together and in each one in particular, is quite incomparable…"

Elsheimer was the first artist to transform the flight of the Holy Family from Herod's henchmen into an atmospheric nocturnal piece. The sensational nature of the painting lies in the fact that its night sky was based on a view through a telescope, an instrument that had just recently been invented. In Venice in November and December 1609, Galileo Galilei had pointed a telescope at the night sky and made pioneering observations. The Milky Way was not a fog but a band made up of myriads of stars – and the surface of the moon was covered with craters and peaks. Galileo published his findings in spring 1610, months after Elsheimer's painting had been finished. In other words, the painter must have visualized what an earlier, more primitive version of the telescope had revealed to him. Even so, he succeeded in creating the first, well-founded depiction of the firmament, the Milky Way, and the richly structured surface of the moon in the history of art.

What makes the painting a work of art, though, is the suffusion of its largely empirical view by a highly subtle narrative and painterly poetry – the events taking place down on earth, the Holy Family proceeding through the world, past a watercourse in which the moon leaves its round, mysteriously luminous mirror image, in front of the dark, magisterial background of a forest edge. Joseph not going before and leading the ass, as the artist had originally planned, but beside and behind it, the burning taper in his hand serving not to light the way but as a symbol of the inner enlightenment the father has experienced or is destined to experience – knowledge of the divine light represented by the Christ child in Mary's arms. No wonder not only Rubens but Rembrandt paid homage to Elsheimer, and were stimulated by his major work – the work considered to this day to be the cardinal creation of Baroque painting, the panel on which the most atmospheric and naturalistic night sky in art history was conjured into being.

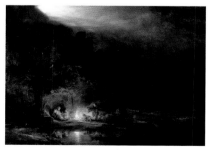

Rembrandt, The Rest on the Flight into Egypt, 1647

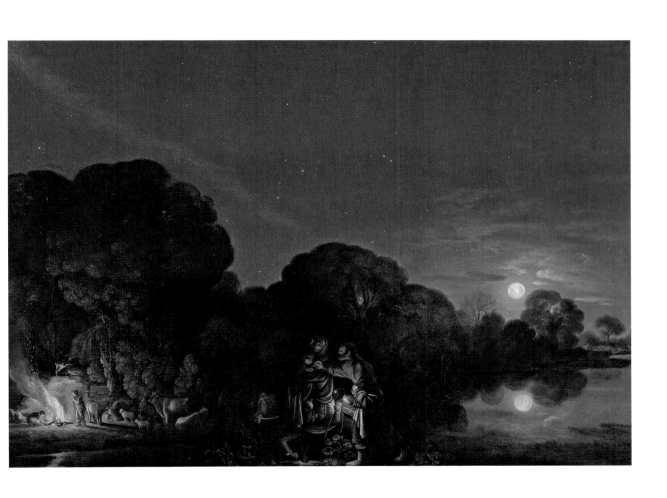

stormy Landscape

Oil on wood, 51.3 x 71.5 cm
Brunswick, Herzog Anton Ulrich-Museum

b. 1606 in Leyden
d. 1669 in Amsterdam

Rembrandt is a figure of outstanding significance not only for the art of the Baroque. Great successes and financial ruin, a brilliant career and social demise mark his biography – a life that has since become overgrown with myths. Much has contributed to Rembrandt's current renown: his Old Testament themes, the penetrating gaze he directed on himself in his self-portraits, or on the personalities of others, reflected especially in his world-famous group portraits. At any rate, in the popular imagination Rembrandt figures principally as a figure painter. It is only in recent years that more attention has been paid to his landscapes. Admittedly Rembrandt, like the great Flemish artist Peter Paul Rubens, painted, drew, and etched no more than a few landscapes – and of the fifteen oil landscapes previously attributed to him, about half have since been ascribed to other artists in his orbit. Yet – and this is decisive – these few examples are among the most realistic and at the same time most imaginative creations in seventeenth-century Netherlandish art, and fascinating highlights in the field of landscape in general.

We can only speculate why Rembrandt did not begin to seriously devote himself to the field of landscape until after his wife's death in 1642, and then for no more than ten years. That such motifs provided the best way of overcoming his grief would seem to belong to the realm of fable. A more plausible argument is that landscape contributed to an expansion of the range of artistic problems he dealt with, to a study of the interactions between light and shade, of spatial arrangements, and of painting techniques. Whatever Rembrandt's mo-

tivations may have been, the results – usually majestic, dramatic panoramas – were breathtaking.

The Brunswick painting is the most spacious landscape Rembrandt ever created. On the rise at the left, bright light picks out a town with church, with trees in the distance and a wide river that forms an imposing waterfall in front of the city. The stream flows under a light-flooded bridge arch on which a towerlike ruin perches. To the right extends a wide plain that is bordered by a mountain chain on the far horizon. The plain, too, is filled with an abundance of details, which nevertheless detract not at all from the experience of a grandiose, dramatic overall view. The lowering, stormy sky, whose drama increases diagonally to the right, establishes a harmonious balance with the accents of light in the left half of the picture. None of Rembrandt's other landscapes recalls more strongly the universal landscapes of the sixteenth century. In the Brunswick painting, landscape is, as it were, distilled into history, the vehicle of a story in which natural forces and man's work grapple with each other – the striking ruin on the bridge serving as a sign which will carry the day.

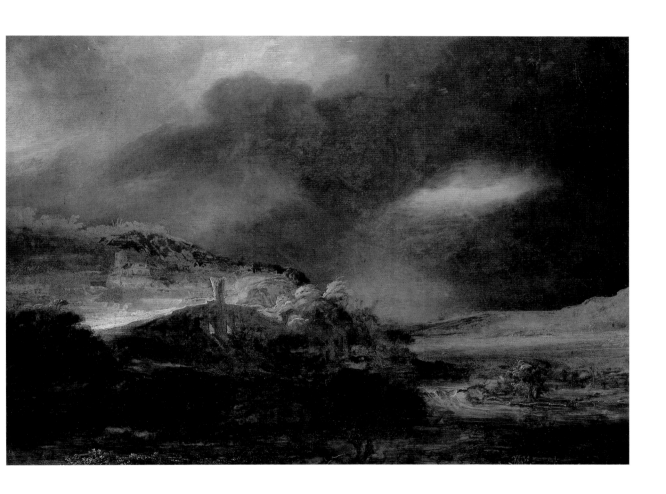

Brazilian Landscape with Anteater

Oil on wood, 53 x 69.4 cm
Munich, Bayerische Staatsgemäldesammlungen, Alte Pinakothek

b. c.1612 in Leyden
d. 1680 in Haarlem

Landscape depictions like the one illustrated here are generally categorized as "exotic landscapes." The concept of the exotic appears to have first cropped up in connection with natural products imported from overseas. From the sixteenth century onwards, exotic goods and products increasingly appeared as requisites in literature, visual art, and theater.

In 1550, in the French seaport of Rouen, King Henry II passed through an avenue of trees with red-stained trunks "like in Brazil." The trees were alive with monkeys and parrots, and huts of reeds and branches perched in their tops. Three hundred men had been tanned with clay, "without covering any of the parts that nature demands be covered – in the manner of the savages of America." Fifty further actors were authentic, having been brought from their homeland expressly for the purpose of the spectacle.

In 1499, the Spaniard Vicente Yáñez Pinzón had become the first European to set foot on Brazilian soil. A year later a Portuguese, Pedro Alvarez Cabral, landed on the coast of the enormous country and took possession of it for his king. Between 1580 and 1640, Brazil – and Portugal – belonged to the Spanish world empire. Yet as early as 1624, the Dutch succeeded in taking the city of Bahia, and in the following years and decades expanded their sphere of influence, especially along the coast.

In the seventeenth century, the short-lived Dutch colony of Brazil initially experienced a remarkably objective depiction, at the hands of a team of observers trained in science, cartography, drawing, and painting. The result was a unique visual report on the country and its inhabitants, flora and fauna. One of the artists involved was the landscapist Frans Post.

Post was a visual reporter in the retinue of Prince Johan Maurits of Nassau-Siegen during an expedition of 1637–1644, which also included natural scientists. One of his tasks was to convey a graphic impression of the exotic fauna and flora to his countrymen back home. "As far as we know," writes Norbert Schneider, "Post actually painted only six landscapes in Brazil and the rest in the Netherlands, probably based on studies and preliminary drawings made in the colony."

Rather than depicting the alien vegetation in all its wild proliferation, Post showed it in a state of beginning cultivation, with broad plains dotted with haciendas and churches. In terms of composition, his landscape views resemble the type of overview landscape practiced in Holland by Philips Koninck (ill. p. 16). Evidently not concerned with sensational effects in view of the exotic environment, Post aimed at a reliable depiction of the topography, to the extent that it had been settled, and of nature in the early stages of domestication. This went hand in hand with a desire to represent the abundance of plant species in an encyclopedic way, especially palms, rubber trees and cacti, but also bushes, ferns and climbing plants or lianas, which the artist tended to arrange into a slightly mysterious, dark foil in the foreground, like the wings on a stage. Behind this extended – again, very much as on a theater stage – an infinite panorama with an airy sky over the horizon.

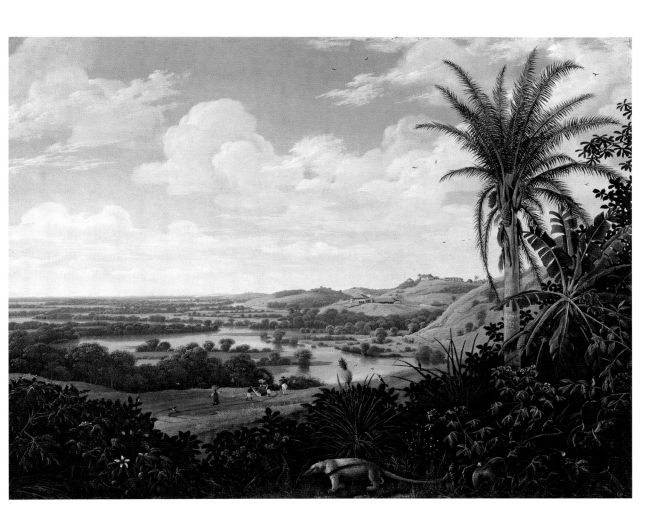

Idyllic Landscape with the Flight into Egypt

Oil on canvas, 193 x 147 cm
Madrid, Museo Thyssen-Bornemisza

b. 1600 in Chamagne
d. 1682 in Rome

Claude Lorrain drew the sum of Italian and northern European landscape painting, and on this basis developed the High Baroque ideal landscape par excellence. The secret of the special effect of depth in Lorrain's paintings lies in his perfection of proportions and perspective. Not even his most talented imitators, of whom there would be myriads in Europe and America in the centuries to come, were able to match it. For all the beauty of his works, however, we should not forget to note their original social function. The palaces of the secular and ecclesiastical elites of the period, not only in Rome, were furnished with an almost unimaginable luxury. The festival held by Philippe d'Aglie in about 1637 in Rivoli, for instance, presented panorama views of the provinces of Savoy, Piedmont, Turin and Montferrat, each in its own room. The dining table was mounted on casters and pushed, complete with diners, from room to room. The party banqueted and danced among the landscapes, and as the people (rather than the setting) were portable, they could imagine they were traveling through the countryside.

Art formed the setting for a society that revelled in pomp and display. Its tendency to the theatrical is also evident in Claude's paintings. To hold their own in opulent surroundings, they needed effective composition and poetic coloration. This is particularly evident in his stagelike views of harbors, except that they far surpass any theater set in terms of their stupendous effects of illumination and space. *Seaport at Sunrise,* in the Old Pinakothek, Munich, is a prime example. In the midst of imaginative scenery, mundane activities like the transport of bales of goods by boat are, as it were, projected back into the arcadian idylls of ancient Greece and Rome.

Most of Claude's paintings were conceived in complementary pairs. This was presumably also true of the landscape with accessory biblical scene illustrated here (one of the artist's rare vertical-format works). It was executed for one of his most important patrons, Lorenzo Onofrio Colonna, chief field marshal of the Kingdom of Naples and one of the most brilliant figures in Roman society of the day.

As in all of his views, Lorrain based this imagined rather than depicted landscape on an idealized distance, fitted out with an iconography of the path. In the foreground and middle ground we see signs of cultural life – pastoral, mythological, occasionally biblical scenes, temples, architecture – which lead the eye to a far-off realm of yearning. At the same time, the artist stages the transcending power of light. It was no coincidence that he was the first artist ever to dare the daunting task of depicting a direct view into the sun!

In these masterpieces of calculated pictorial construction, a wonderful balance between positive and negative forms dominates – a measure and order, a control of effects based on the rules of French neoclassicism, intended to raise "ordinary nature" to the status of the sublime.

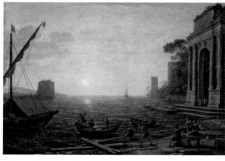

Seaport at Sunrise, 1674

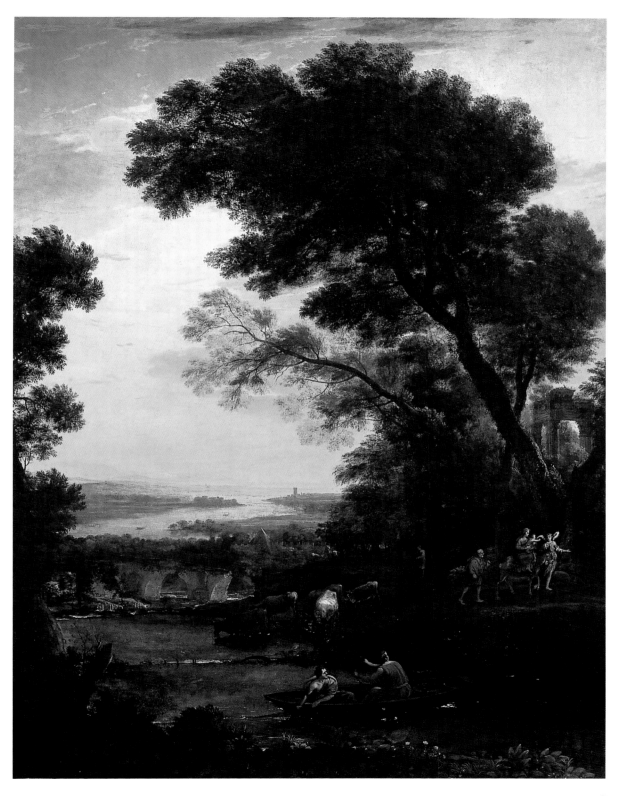

тhe мill at wijk near Duurstede

Oil on canvas, 83 x 101 cm
Amsterdam, Rijksmuseum

b. 1628/29 in Haarlem
d. 1682 in Haarlem

Jacob van Ruisdael was one of the most significant landscapists of the seventeenth century, the Golden Age of Dutch art. He created several "icons" in the field, whose message goes far beyond the beauty and poetry of the landscape panorama and the objective, topographical rendering of excerpts from nature to take on symbolic force.

This is especially true of his superb *View of the Bleaching Fields outside Haarlem*. The striking thing about this view is the effect of extreme depth, achieved despite the very low horizon, primarily by means of the expanse of sky, articulated with cloud formations. The beauty of Ruisdael's home town and environs surely reflects the civic pride that arose in the wake of the liberation of Holland and Haarlem from the Spanish occupation.

A possibly even more overwhelming example of Ruisdael's landscape art is *The Mill at Wijk*. Wijk by Duurstede lies at the point where the Rhine divides into the Lek and the so-called Crooked Rhine. At the far right, the unfinished, blunt spire of St. John's Church in Wijk rises into the picture. Likewise identifiable in the background is the castle, the ruins of which are still there today. The mill, in contrast, has not survived, except for a few remnants of its foundation. In that it depicts certain features of the local environs and thus recognizes them as worthy of inclusion in art, this is a typical work of Dutch seventeenth-century painting – and one of the finest.

The way the windmill is isolated against sky and land is instructive. This calculated composition, only apparently objectively recapitulating the existing scene, is the result neither of pure artistic imagi-

nation nor of pure empirical observation. The confrontation of the windmill vanes with the dramatically towering clouds in the background engenders, on the one hand, a striking depth of vision, while on the other underscoring the mill's presence as a soaring monument. A windmill is not only a work of man subject to the forces of nature; it is also a place of vision. In the fifteenth century, the theologian and philosopher Nikolaus von Kues distinguished "speculative cognition," what he called "tower knowledge," from a merely discursive knowledge "in which man follows, like a hunting dog, traces over the field which he simultaneously surveys at once and as a whole from the high tower of the speculative." The structure's free-standing site as a place of recognition nobilitates the mill at Wijk. Nor does Ruisdael's picture lack an observer, standing in the gallery of the tower.

The construction of a continuous landscape depth based on the guideline of a diagonal in space, demonstrated in this masterpiece, was first achieved by Elsheimer in his *Flight into Egypt* (ill. p. 45).

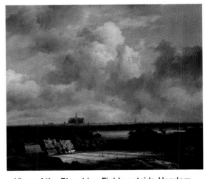

View of the Bleaching Fields outside Haarlem,
c. 1670–1675

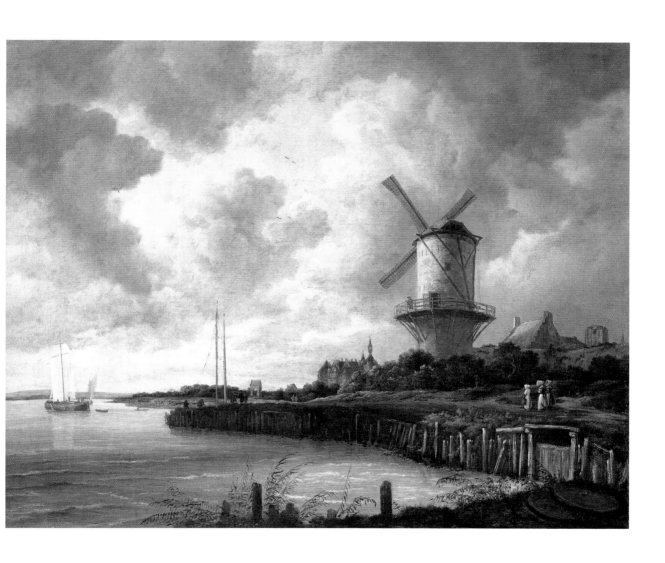

нeroic Landscape with Rainbow

Oil on canvas, 188 x 171.2 cm
Munich, Bayerische Staatsgemäldesammlungen, Neue Pinakothek

b. 1768 in Obergiblen
d. 1839 in Rome

In 1814, Johann Georg Dillis (1759–1841) requested to be relieved of his post as professor of landscape painting at the Munich Academy. The academic notion that landscape was far inferior to history painting because it entailed mere imitation of nature, Dillis explained, ran entirely counter to his own naturalistic approach. The art of Joseph Anton Koch was quite differently received by official Munich. An eloquent detractor of such naturalism, Koch wrote in 1810 that "mere imitation of nature is far below art; even when art appears natural, it should be in the exalted style of the artistic genius who, as it were, converts nature." Koch executed a series of paintings along these lines which are described as "heroic landscapes," the most outstanding of which is *Heroic Landscape with Rainbow*. It exists in three versions, in Karlsruhe, Munich and Berlin.

A native of Tyrol, Koch joined the Jacobins in revolutionary Strasbourg and conducted nature studies in the Swiss Alps before going to Rome, where he took classical art and literature as his guidelines. Gradually his approach developed from the pure landscape depictions of his Swiss watercolors to landscapes whose accessories and figures charged them with historical meaning. In art, as Koch put it, "history and nature… can be depicted… separately as little as God separated them in the history (of mankind)."

The picture spirits the viewer into a distant and bygone world. Shepherds and shepherdesses of various ages populate what Koch himself described as a "rainbow landscape after a storm, the likes of which can be seen in southern Italy (Salerno) or in Greece." The view extends from copses of trees and gentle river valleys to sunny fields and rugged mountains, on whose slopes we see ancient and medieval cities, ideal pictures of communal life. The rainbow, a symbol of divine mercy, links heaven and earth, ancient and Christian life, in a harmonious unity. According to the artist, it was accessories and figures that infused a landscape with ideas and meanings, making it an "idyllic poem in painting" comparable to classical poetry in this vein. In the late eighteenth century, the middle class could identify with the era evoked in such heroic landscapes insofar as it had become conscious of itself in the wake of the French Revolution and abandoned its accustomed privacy to help shape public affairs. The heroic past became an obligation and challenge to make the world the kind of harmonious place that was embodied in classical poetry and painting.

In all of Koch's paintings, nature retained its inviolable, indestructible grandeur and dignity. Another prime example is his depiction of the *Schmadribach Falls* (Munich, Bayerische Staatsgemäldesammlungen, Neue Pinakothek), a scenic spot in the Bernese Highlands. Certain alterations were made in the geographically precise view and the abundance of topographical details – such as the snowcap added to the mountain on the left, the Grosshorn – in order to heighten the poetic expressiveness and sublimity of the scene.

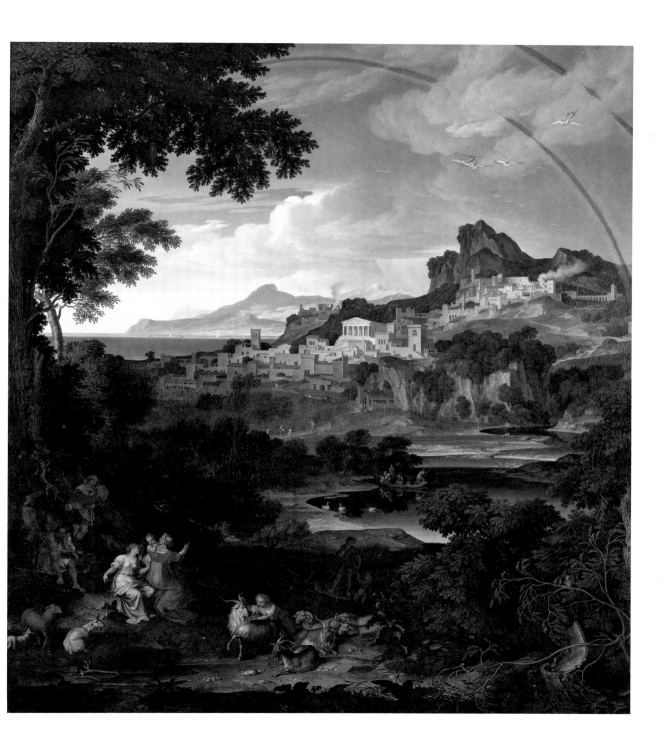

тhe wanderer above the sea of ꜰog

Oil on canvas, 98.7 x 74.8 cm
Hamburg, Hamburger Kunsthalle

==

b. 1774 in Greifswald
d. 1840 in Dresden

Caspar David Friedrich, protagonist of German Romantic art and one of the greatest of European landscapists, painted his famous *Wanderer above the Sea of Fog* in 1818. It embodies the quintessence of the principles of the Romantic landscape aesthetic. In the foreground we see the dark silhouette of a rocky promontory, where a wayfarer stands looking out over dense fog and spires of rock in the valley towards distant mountains and peaks. High above these stretches a bank of clouds. The scenic excerpt is dominated by the deep space of a vista, prompting us to wonder what lies beyond. Friedrich did the exact opposite of what he criticized about academic landscape painting, which, he wrote, "mercilessly compresses everything (seen) in a circle of 100 degrees in nature into a 45-degree field of vision." As a result, everything in nature that "lay separated by large intervals… jostles in a constricted space, overfilling and oversatiating" the eye, and "making an adverse and frightening impression" on the viewer.

A further crucial feature of the composition is its reliance on the effect of the sublime, which the great English Romantic poet, Lord Byron, clothed in the question: "Are not mountains, hills and clouds a part of myself and my soul, just as I am a part of them?" And Carl Gustav Carus recommended in 1835 that people "step out onto the summit of the mountains, gaze over the long rows of hills, observe the running of the streams and all the magnificence that presents itself to your eyes… You lose yourself in limitless spaces… Your ego vanishes, you are nothing, God is all."

The figure seen from the back very likely represents a patriotic memorial to a countryman who died in the Napoleonic Wars. The fog perhaps symbolizes the cycle of nature, a natural phenomenon that has become a synonym for a metaphysical idea. Possibly, however, the fog spreading through the valley carries the historical connotation of an "unenlightened" past, and the light-filled sky that of an emerging political liberalism. One is tempted to quote the philosopher Jean-Jacques Rousseau, who in the mid-eighteenth century described the purifying effect of the high mountains by reference to the ether, the matter of the highest divine heaven, the fifth element or *quinta essentia.* Friedrich's deceased "universal wanderer" gazes beyond the fog and peaks into etherial realms, into the divine quintessence that brings tranquillity. Although Friedrich expresses the aspect of sublimity in a subjective experience of high altitudes, he nevertheless attempts to transcend it as well.

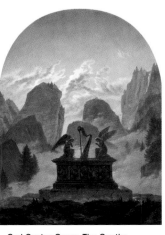

Carl Gustav Carus, The Goethe Monument, 1832

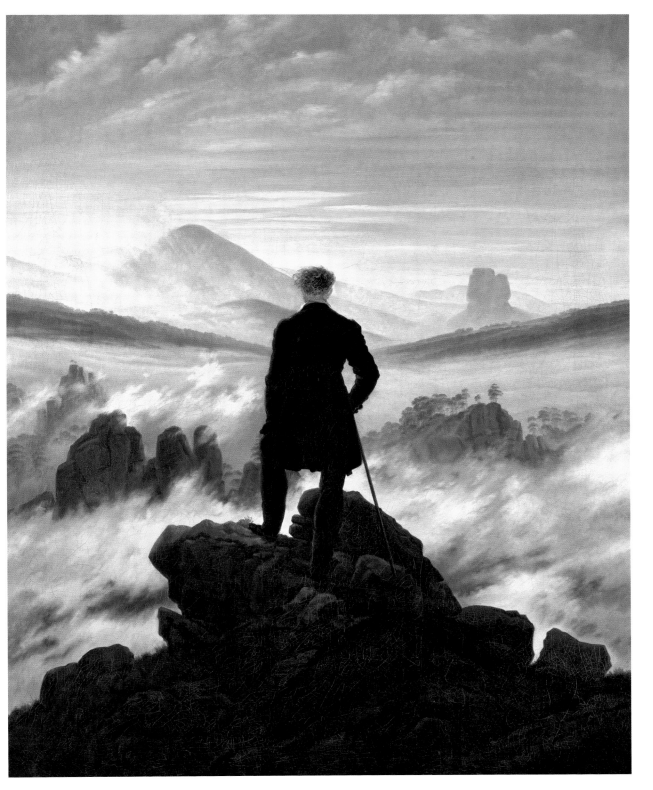

The Lock

Oil on canvas, 142.2 x 120 cm
Madrid, Collection of Carmen Thyssen-Bornemisza, on loan to the Museo Thyssen-Bornemisza

b. 1776 in East Bergholt
d. 1837 in London

The English artist John Constable is one of the greatest of European landscape painters, whose handling of light and color was admired by the masters of Barbizon and the Impressionists, among others. His pioneering division of colors was described by Delacroix in a journal entry for September 23, 1846: "Constable said that the superiority of the green of his fields was due to the fact that it was composed of a number of different greens. The lack of intensity in the green of normal landscapes was a result of it being represented by a single hue. What he said here about the green of fields can be applied to every other color."

The Madrid painting represents the locks of Flatford Mill on the Stour. Constable knew the place from childhood, because his father owned the mill. Every work the artist exhibited at the Royal Academy from 1812 to 1825 included a view of the Stour Valley.

Constable made several studies outdoors for his large-format pictures. In preparation for *The Lock,* he travelled from his residence in Hampstead outside London to Dedham in spring 1823. That the finished paintings never adhered slavishly to such sketches, but rather modified natural appearances in the service of the picture's message, is indicated by *The Lock,* which shows three significant changes with respect to the studies: first, the invented group of trees on the right; second, the locks themselves, which Constable depicted in the state of dilapidation he knew from his childhood, despite the fact that they had since been repaired under pressure from the people of Dedham and neighboring villages. Third, the artist altered the position of the man in the red vest at the lock gate, making him the center of the composition by relating the figure's silhouette to the distant church spire.

The principal effect of the composition, however, derives from the landscape scene itself, which is characterized above all by the treatment of light. The light seems to fluctuate before our eyes, analogously to the meteorological interplay in the sky. In his differentiation of lighting effects under clouds of varying density, Constable relied largely on seventeenth-century Dutch Baroque landscapes, especially those of Jacob van Ruisdael. The present painting employs the identical technique of representing an agitated water surface by means of white impasto.

Due to the unique qualities of its illumination, this picture is one of the culminations of Constable's oeuvre. The fundamental tenor of the landscape evokes reverberations of a paradisal state, even if it is one already threatened by the signs of agriculture in the distance and the city encroaching upon the countryside.

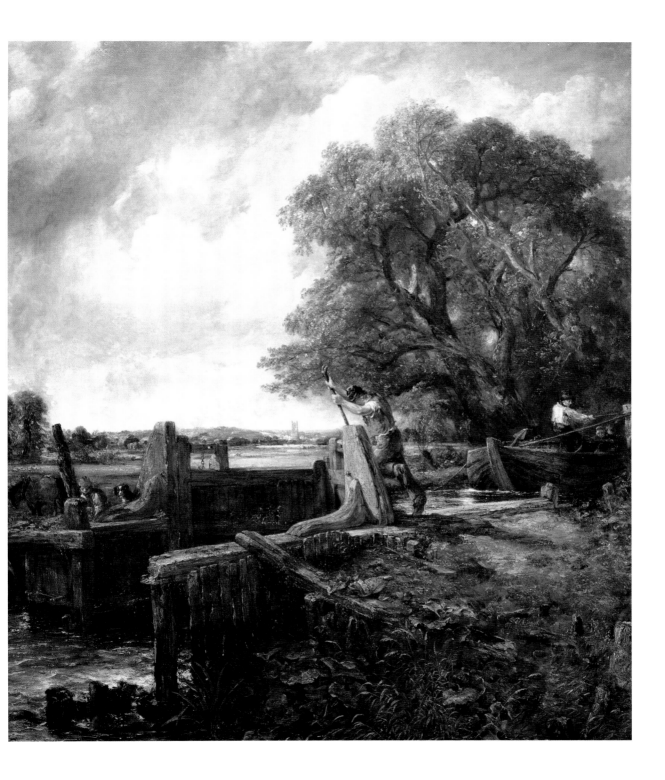

Rain, steam, and speed – The Great western Railway

Oil on canvas, 91 x 122 cm
London, The National Gallery

b. 1775 in London
d. 1851 in London

William Turner painted nature like no other artist before him, as a cosmos of color and light. John Ruskin (1819–1900), in his 1843 book *Modern Painters,* said that this genius was concerned with a modern and progressive vision that would reinstate what might be called "the innocence of the eye." Orientation was provided by Claude Lorrain's landscapes and Edmund Burke's reflections on "the beautiful and sublime." Turner first saw a Lorrain picture, a seaport, in 1799, and immediately decided that this was the way to paint light. Lorrain's airy gradations and view of the sun seemed insurpassible. Never, Turner thought, would he achieve this mastery. He was mistaken.

Rain, Steam, and Speed is horizontally divided into two halves, the upper zone consisting of a relatively loose texture of yellows heightened with large passages of white and interspersed with scattered grayish-blue shadows. This color scheme is easily read as an atmospherically agitated sky. The lower half of the picture, in contrast, is rendered in a coloration so diffuse and vague that it would be hard to decipher, had Turner not added a small boat and the great bridge, substantial signs from which the whole can be reconstructed as a landscape.

Towards the right and the lower edge, the colors condense into an increasingly clearly contoured blackish-brown diagonal representing the bridge at Maidenhead, over which a train approaches the viewer in a perspective evocative of motion. White and red paint particles applied with a palette knife to the black locomotive suggest its spark-spraying energy. This diagonal is crossed in the opposite direction by strokes of paint that evidently represent windblown rain catching the sunlight. Turner additionally underscores the precipitous speed he wishes to evoke by depicting a hare – difficult to discern – racing along the tracks in what is likely a vain attempt to escape the locomotive.

The painting not only illustrates the beginning railway era, but itself has the look of a fleeting impression from a moving train. Reputedly the artist once leaned out of the compartment window of a train in the pouring rain to study the new perceptions to be had at high speed – the visual blurring of a vanishing point and the way the foreground went out of focus as one rushed past it.

The German artist Adolph von Menzel (1815–1905) would not have known Turner's picture when he painted his own famous railroad depiction in 1847. Although its composition and paint handling are quite different, Menzel too confronts an organic, relatively unsullied nature with a railroad right of way mercilessly driven through it. And as a meandering path leads gently to the destination in the background, the suburbs of Berlin, the train rushes away from the city with mechanized rapidity.

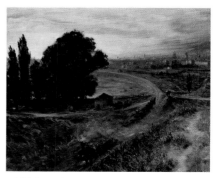

Adolph von Menzel, The Berlin-Potsdam
Railway, 1847

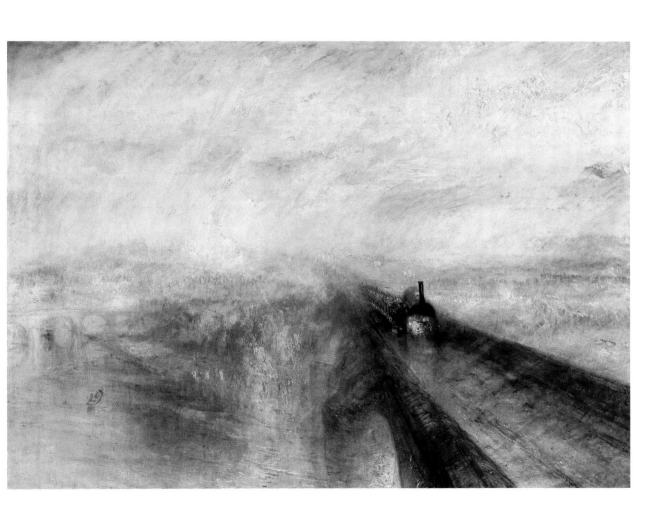

Landscape with setting sun (Etude de ciel au soleil couchant)

Pastel on grayish-blue paper, 22.8 x 26.8 cm
London, The British Museum, Department of Prints and Drawings

b. 1798 in Saint-Maurice-Charenton
(near Paris)
d. 1863 in Paris

Who doesn't know them, the highlights that ensured the foremost representative of French Romanticism, Eugène Delacroix, of his place in the pantheon of art? Those works in the Louvre that have long since entered the public consciousness worldwide: *The Barque of Dante* (1822), *The Massacre of Chios* (1824), *The Death of Sardanapolis* (1827), and *Liberty on the Barricades* (1830) – all of them monumental history paintings and allegories. Inspiration for the no less astonishing composition *Women of Algiers* (1834, likewise in the Louvre), a harem scene, came from the artist's famous journey to Morocco in 1832. In view of an oeuvre like this, Delacroix's merits as a landscape painter tend to be overlooked.

Still, his motto, formulated in 1863 – "The foremost merit of a painting is to be a feast for the eye" – celebrates a painterly sensuousness that was equally reflected in his few landscape studies. The pastel illustrated here is a superb example.

In connection with his work on a monumental ceiling painting for the Apollo Gallery in the Louvre, in 1849/50 Delacroix made pastel studies from nature, focusing on the coloristic effects of evening light. Each of these depictions is based on the same compositional scheme. Above a narrow, slightly curved strip of landscape, a vault of sky rises over the horizon to occupy the larger part of the sheet. Unlike in the other works in the series, here Delacroix does not differentiate the landscape gradations, instead opening up the composition by repeating the blue towards the edge of the sheet. The intense coloration ranges from contrasts of blue and yellow to flecks of orange.

Delacroix is fascinated by the effects of a fleeting visual impression, the display of colors in the sky that lends the landscape a striking mood. Astonishing, how few strokes he needs to set off the dark, clearly contoured terrain below from the atmospherically modulated expanse of sky.

Delacroix's interest in evanescent, rapidly changing natural pheneomena would exert an irresistible attraction on the Impressionists a few decades later. It was no coincidence that the present pastel came into the possession of Edgar Degas (1834–1917), who was inspired by it to make his own landscape studies. Recent commentators have even gone so far as to view works like *Landscape with Setting Sun* as brilliant anticipations or forerunners of the late work of Claude Monet (1840–1926).

"we (= Delacroix and villot) have observed astonishing color effects on our walk. it was at sunset: the most brilliant chrome and carmine hues next to the light, and immeasurably blue, cold shadows. similarly the shadows on the entirely yellow trees, terra di siena and reddish brown and illuminated by the sun, set off by an area of gray clouds shading into blue."
Eugène Delacroix, 1850

yosemite valley at sunset

Oil on cardboard, 30 x 49 cm
Private collection

**b. 1830 in Solingen, Germany
d. 1902 in New York**

In the latter half of the nineteenth century, American landscape painters of the Late Romantic school often suffused their compositions with an unreal illumination intended to symbolize Christian salvation. Their aim was to evoke the transcendence of light as a sign of divine mercy. Expanses of sky over a broad horizon were rendered in intense reds, yellows and violets, a color range unknown to European painting, in spite of William Turner.

A native of Germany, Albert Bierstadt discovered the American wilderness for art, applying these means in the tradition of Claude Lorrain (ill. p. 51). In 1863, Bierstadt and the writer Fritz Hugh Ludlow set off on an expedition to the Wild West, which took them thousands of miles through the dramatic scenery of Colorado, Wyoming, Utah, Nevada, California, and Oregon. The artist captured these impressions in a series of large-format panoramas that made him the founder of the Rocky Mountain School.

Yosemite Valley at Sunset was a preliminary study for one of these large paintings. As dramatic as the area is in reality, Bierstadt heightened it still further, plunging the scene into a veritably mythical illumination that verges on the spectacular technicolor effects of Hollywood movies to come. Still, Bierstadt's views and the stereoscopic photographs his two brothers made of the Yosemite Mountains contributed to the declaration of the area as a national park. The Romantic sublime, it seemed, could be rescued only in the form of nature preserves.

Bierstadt stood in the tradition of the Hudson River School, founded by the English-born Thomas Cole (1801–1848), which marked the beginning of a genuinely American landscape painting.

Cole's most significant successor was Frederic Edwin Church (1826–1900). Church's landscapes represented unsullied nature as an embodiment of his faith in the God-given strength and mission of the New World, "America's sacred destiny," as he put it. An example is *Niagara Falls,* an icon of American painting. The extremely wide format, the horseshoe shape of the falling masses of water, and the horizontal stretch of land in the background, visualizing the incredible extent of this natural wonder, lend the picture the monumentality of a gigantic panorama. The falls and the immense, untouched landscape become a natural symbol of the political energy of a people and nation devoted to making the world a better place to live in. The violet hue of the sky and the rainbow blur in the rising mists, conveying a sense of mystery that lends the natural motif a symbolic aspect.

Frederic Edwin Church, Niagara Falls, 1857

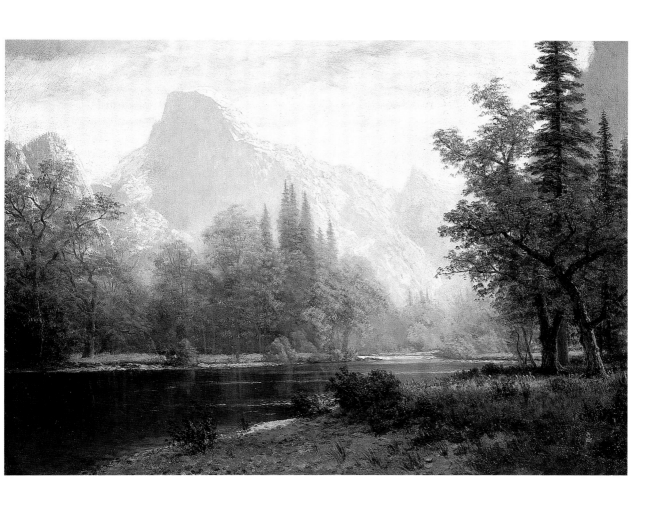

тhe solitude.
recollection of vigen, Limousin

Oil on canvas, 95 x 130 cm

Madrid, Collection of Carmen Thyssen-Bornemisza, on loan to the Museo Thyssen-Bornemisza

b. 1796 in Paris
d. 1875 in Paris

The Barbizon School played an outstanding role in the history of modern landscape painting. This was a group of young artists who in the 1830s and 40s sought the beauties of the unsullied landscape, a rural idyll, the undramatic yet inspirited *paysage intime* in the forest of Fontainebleau. They finally settled in the village of Barbizon, where they were occasionally joined by Camille Corot, the major artist of the group. Corot's works embody the essence of a landscape painting of airily rendered, basically ordinary scenes populated now and then with mythological figures. These were alternative images to an economically and touristically exploited nature. Inspiration came from seventeenth-century Dutch landscapes and those of the Englishman John Constable (ill. p. 59), but especially from the new turn to open-air painting and its capturing of atmospheric, evanescent effects. This notwithstanding, Corot generally finished his works in the studio. Using a limited range of color, especially earthy greens, a silvery gray, ocher and their gradations, contrasted with a bright sky, Corot engendered a lovely, melodious harmony that clothed nature in a Late Romantic, magical mood.

Corot finished his *Morning, Dance of the Nymphs* in 1850. Acquired by the French nation in 1851, it was the only work that was officially exhibited during the artist's lifetime. And it was Corot's earliest depiction of dancing nymphs in a landscape – in this case wooded and shadowed towards the margins – in which the ancient god of wine and orgiastic revelry, Bacchus, appears in the left background. The pattern for the composition was Claude Lorrain's famous *Landscape with Rural Dance* (Paris, Musée National du Louvre). A sense of music permeates the play of light and shade, and the silvery gray hue that lies like a veil over the scene. Landscape becomes a site of synaesthetic sensations, the mythical figures serving as embodiments of human dreams and yearnings projected into nature. Yet the writer Emile Zola, for one, was not impressed. In his review of the 1866 Paris Salon, he declared, "If Camille Corot were willing to kill the nymphs that populate his forests for one and all time, and replace them with peasant women, I would love him immeasurably. I know that diaphanous creatures, dreams veiled in mist, belong to this delicate foliage, this smiling, damp rosy morning. This is why I am sometimes tempted to request from the master a more human, rawer nature."

In *The Solitude,* the artist has done without all mythological trappings. A female figure, reclining and as if lost in thought, is sufficient to lend this, one of the Barbizon master's most elegiac landscapes, an incomparable mood of loneliness and yearning. The art critic Castagnary found an apt phrase for this in 1892: *la nature revée,* or "dreamed nature."

Morning, Dance of the Nymphs, 1850

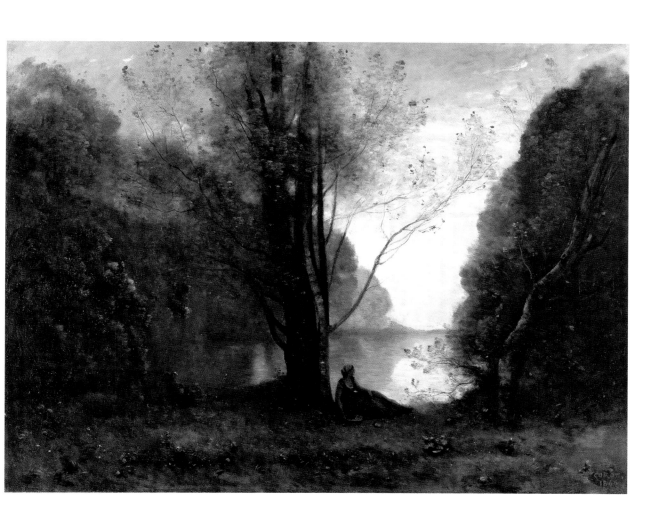

Nocturne in Blue and Gold: Old Battersea Bridge

Oil on canvas, 66.7 x 48.9 cm
London, The Tate Gallery

b. 1834 in Lowell (Mass.)
d. 1903 in London

When in 1863 the jury of the Paris Salon rejected so many works that a Salon des Refusés had to be called into being, both Edouard Manet and Whistler exhibited there. Whistler's paintings, like those of his French colleague, nevertheless continued to be scoffed at, while run-of-the-mill art was acclaimed.

Born in the United States, Whistler studied in Paris, and was befriended with Monet and Renoir. From 1863 onwards he lived in England, where a series of public scandals made him the bohemian idol of young artists who would become major representatives of British Impressionism. From the 1880s, they also adopted and developed traits of pre-Impressionist English landscape painting. Their recurrence to William Turner's (ill. p. 61) and John Constable's (ill. p. 59) landscapes was apparently a reaction to increasing industrialization and the explosive growth of the cities.

Due to early influences from seventeenth-century Dutch landscape painting and the art of the Far East, Whistler, despite his contacts with Impressionism, was anything but a pure Impressionist. His delicately hued compositions in light and color possess a meditative planarity in which his eminent graphic talent comes to the fore. His etchings are reminiscent of Chopin's études, especially the melancholy Venice motifs. With musical titles such as *Symphony* and *Nocturne,* these drew some of the highest prices for prints on the international art market of the day.

The small painting *Blue and Silver – Chelsea,* of 1871 (London, The Tate Gallery), was Whistler's first *Nocturne,* or night piece, in oil. The objects and details of the landscape are visible as mere silhouettes, the true content of the picture being the evening twilight as reflected in the water. Only suggestions of topographical details are detectable; the spire of Old Chelsea Church on the horizon at the right indicating that the scene was depicted from Battersea, looking across the Thames. Any topographical description, of course, becomes secondary in view of the atmosphere and magical mood of Whistler's picture.

The motif of *Nocturne in Blue and Gold* is Old Battersea Bridge and the Thames landscape by night. The influence of Japanese woodblock prints is evident in the brilliant reduction of the scene, in which each form and delicate gradation of color relates to a musical component as well, an approach that runs counter to traditional perspective. In subsequent works Whistler would treat foreground, middle ground, and background in even more equivalent terms.

For Whistler and his contemporaries, twilight possessed an ambivalent charm. It was the intriguing "blue hour," the moment when dreams took shape. Dreams and musings infuse both the senses and the passions, as Charles Baudelaire revealed in *Les Fleurs du Mal,* or *The Flowers of Evil.* In this regard, Whistler's nocturnal landscapes hold a key position in the world view of Symbolism.

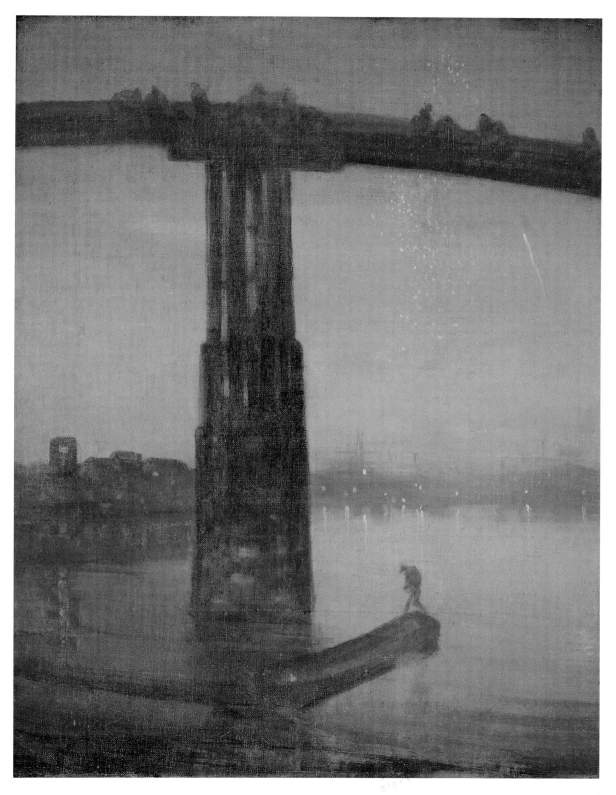

тhe ısland оf the рead

Varnished tempera on canvas, 111 x 155 cm
Basel, Kunstmuseum Basel

b. 1827 in Basel
d. 1901 in Fiesole

The Island of the Dead is the Swiss artist Arnold Böcklin's most famous composition. Beginning in 1880, he painted five modified versions, four of which have survived (Basel, Kunstmuseum; New York, The Metropolitan Museum; Berlin, Nationalgalerie; and Leipzig, Museum der bildenden Künste).

Each version of the painting shows a magically illuminated island rising from the sea against a gloomy night sky. Burial chambers have been carved into the rocky cliffs around the natural harbor, with dark cypresses rising above them. A boat with a coffin, a statuesque figure swathed in white like a mummy and gazing away from the viewer, and an oarsman glides slowly across the water towards the island (although judging by the oarsman's position, the boat should actually be moving away from it!). Although we can almost hear the soft splashing of the oars, this only heightens the incredible silence that pervades the scene – a "visual silence" underscored by the equilibrium of horizontals and verticals. The low-lying horizon creates an impression of endless depths. The sparingness of the composition is matched by the palette: reddish rocks reflecting the last evening sunlight, the eerie white of the figure in the boat, the deep blue and violet of water and sky (which in other versions is stormy), and the dark, nearly blackish green of the cypresses. Many attempts have been made to find the original model for this mysterious island: the cemetery island of St. Jurai south of Dubrovnik, Pontikonissi off Corfu, and one of the Ponza Islands in the Golf of Gaeta have been suggested. But an identical correspondence for Böcklin's fascinating view has been found nowhere in reality.

Beyond its evocation of life's transience, the potential meanings of this major work of Symbolism have yet to be entirely decoded. Nor, apparently, were they ever intended to be, because the lady who commissioned the painting, Marie Berna of Frankfurt am Main, had desired "a picture to dream over," and Böcklin himself envisioned its effect as being "so silent that you would get a fright when there was a knock on the door." The meaning of the enigmatic image ultimately remains up to the viewer's imagination. The viewing of art, a landscape unsurpassed in suggestive power, becomes a creative act that complements the creativity of the artistic process.

In 1974, Fabrizio Clerici (1913–1993), a Milanese architect, painter, graphic artist and stage designer, made a paraphrase of *The Island of the Dead*. It was a reaction to the fact that Böcklin's landscape was one of the most frequently reproduced pictures of the nineteenth and twentieth centuries, and as such was inevitably trivialized, to the point of kitsch. Clerici released the picture from this opprobrium by dissecting it and arranging its separate parts like set pieces – especially by robbing the Elysian island of its nocturnal atmosphere and plunging it in bright, exhibition light. The subjective mood of the motif made way for an analytical exploration as the landscape became a factor in a complex formal experiment.

Fabrizio Clerici, The Presences, 1974

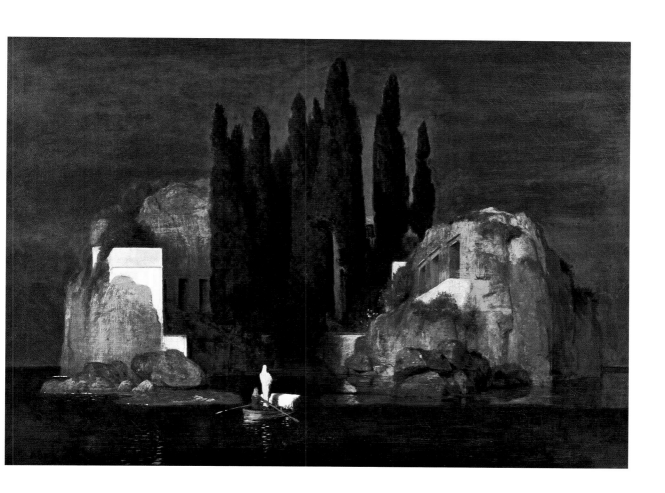

starry Night

Oil on canvas, 73.7 x 92.1 cm
New York, The Museum of Modern Art

**b. 1853 in Groot-Zundert
(near Breda)
d. 1890 in Auvers-sur-Oise**

Like many other van Gogh paintings, *Starry Night,* an evocation of the fatefulness of the nighttime hours painted from the barred window of a cell in the Sainte-Rémy insane asylum, relies on the motif of trees.

Two of the cypresses so typical of the artist – trees symbolic of death – rise vertically like flaming torches parallel to the left edge of the picture. Visible behind them, as if pressed down by the horizontal of a mountain ridge, are the small houses of a village where a few lights are burning. The course of the horizon is interrupted only by a church spire, pointing like a finger towards heaven. Between village and mountains spread olive groves in regular billows.

The main feature of the composition, however, is the night sky, in which the tiny lights in the human dwellings below are amplified to apocalyptic proportions. The flaming rings that appear there no longer have anything in common with the romance of gentle starlight and moonlight. Rather, the violence of the brushstrokes and heavy impasto paint convey an impression of exploding galaxies.

For van Gogh, the night sky was a metaphor for the mysterious universe. As he once admitted to his brother, Theo, he felt a "terrible need for – shall I say the word – religion, … then I go outside in the night and paint the stars…"

As in a whirlwind engulfing the entire firmament – sketched in energetic hatchings to correspond with the overall surface texture – the nocturnal dark blue is permeated by sinuous bands of light and bright stellar coronas. The composition reaches a grandiose culmination in the motif of the waning moon with halo at the right edge. The

American art historian Albert Boime believes that beyond the emotionally expressive quality of the composition, one of van Gogh's most significant works, *Starry Night* contains a substantial statement – an attempt on the artist's part to read his destiny in the stars and render it visible. The darkly agitated yet so luminous night sky, Boime says, can be understood both as an inquiry into the artist's future and as a utopian model of salvation. All of this conforms with what van Gogh admired about the American poet Walt Whitman, who was "someone who sees a world of healthy, sensual love in the future and even in the present, daring and free – a world of friendship, of work under the wide, star-studded firmament – something one can ultimately only call God and Eternity…"

Even though this interpretation may go too far in detail, one thing remains incontestable: the painting's translation of a universal drama into an aesthetic event, a handling of form and color that conveys the submission of the dark earth under the well-nigh violent dominion of the stars. Apart from the symbolism of this landscape cowering beneath the infinity of the universe, van Gogh's painting rests on empirical facts, by no means denying its basis in nature. This places it in the tradition established by Adam Elsheimer (ill. p. 45), in which a precisely observed starry sky makes a crucial contribution to the iconography.

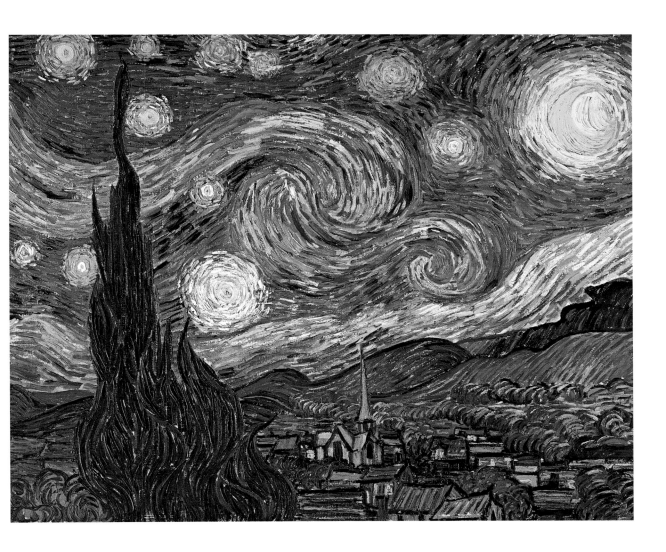

Poplars. Three Pink Trees in Autumn

Oil on canvas, 92 x 73 cm
Philadelphia, Pennsylvania, The Philadelphia Museum of Art, Chester Dale Collection

b. 1840 in Paris
d. 1926 in Giverny

To symbolize an earthly paradise in landscape – where but in Impressionism has this aim been more convincingly achieved? Landscape is generally viewed as the principal subject of this direction in art.

After the greatest Impressionist, Claude Monet, had completed his series of "Haystacks," he addressed a further landscape motif – "Poplars," in a series of paintings based on studies made outdoors. The story of these trees in Limetz has been recorded. They were to be cut down and sold to a lumber dealer. Monet paid a certain sum for the poplars, under the condition that they be left standing until he had finished painting them. *Poplars. Three Pink Trees in Autumn* clearly illustrates the consequences of the subject for Monet's art. On the one hand, it confirms the fact that for this painter, nature was a visual event. This is the typically Impressionist component of the picture. Yet conversely, the verticals of the trunks lend the composition a rhythmically structured solidity that runs counter to the typically Impressionist flickering surface and engenders a covert pictorial geometry to which a protagonist of geometric abstraction, Piet Mondrian, would later be able to refer. This consolidation appears to spread to the dabs of color, which on the whole recall the regularity of Pointillism without going so far color division.

The Neo-Impressionists or Pointillists would systematize the Impressionist division of color into increasingly abstract, regular patterns of dots, a kind of screen that lay over and absorbed everything in the picture. This principle is illustrated by *"Le Bec du Hoc," Grandcamp* by Georges Seurat (1859–1891).

In his Grandcamp seascapes the grand master of Pointillism took the refinement of brushwork to an extreme, producing a finely patterned paint surface of great homogeneity. The most famous painting in the series shows the "Bec du Hoc," a rock east of Grandcamp whose massive formation Seurat depicts rising over the horizon "almost like a wave turned to stone," as Hajo Düchting puts it. It was surely no coincidence that the abstracting tendencies of Pointillism developed largely, if not exclusively, in the subject of landscape, because in the nineteenth century it was less charged with meaning than other subjects and therefore virtually predestined for formal experiments.

Georges Seurat, "Le Bec du Hoc," Grandcamp, 1885

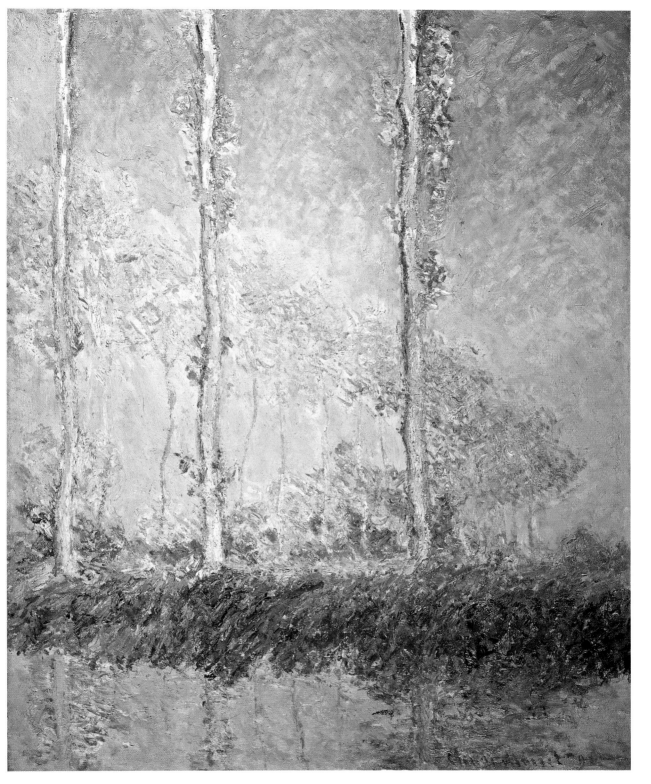

ᴛahitian ʟandscape with mountains

Oil on canvas, 68 x 92.4 cm
Minneapolis, Minnesota, Minneapolis Institute of Arts, Julius C. Eliel Memorial Fund

**b. 1848 in Paris
d. 1903 in Atuana**

Working alongside Émile Bernard, Louis Anquetin, and Paul Sérusier in the artists' village of Pont-Aven, Gauguin developed a style with an extreme emphasis on line and plane. Highly colored motifs were flattened into the picture plane and encompassed with heavy, sweeping contours that took on a rhythmical life of their own. An illusion of depth was avoided, and modelling light and shade played little role. The representatives of this School of Pont-Aven, which flourished in the years after 1886, called their style "Synthetism". Due to their frequently religious and visionary subject matter and their intention to create less from nature than from dream, idea and imagination, these artists are often associated with Symbolism.

It was typical of Gauguin to accuse the Impressionists of superficiality, of searching only in the compass of the eye rather than in the mysterious center of the psyche, and it was typical of him to go on to criticize the Pointillists for their cold-blooded rationality. Yet himself determined to reduce appearances to formulas, he increasingly began to shape forms by means of continuous, flowing lines. It was a formalization that, along with his "unrealistic" color, aimed at the emotional, symbolic and archaic – as even the treatment of a motif as mundane as *The Yellow Haystacks* of 1889 (Paris, Musée d'Orsay) indicates. It was also his search for the primitive that led Gauguin to find meaning in as yet emotionally unsullied regions.

The "discontents with civilization," in the sense given to this sign of modernism by Freud – the suffering under a life lived at second-hand, based on a permanent repression of emotions and instincts – accompanied Gauguin from the beginning. In that period many French artists turned their back on the big city. Cézanne and van Gogh, Impressionists and Post-Impressionists sought a new intensity of color and light in regions yet to be touristically exploited, in the South of France, in Provence, on the Côte d'Azur. Yet none of them played the role of cultural drop-out more seriously than Gauguin. In 1891, he made his first escape to Tahiti, only to find that this "island of bliss" had long since been ruined by civilization. Colonialization had turned "noble savages" – to use the philosopher Jean-Jacques Rousseau's term – into prostitutes and drunken jetsam, as Gauguin soon lamented.

In 1897, back in the South Pacific, the artist painted the huge canvas *Where Do We Come From? Who Are We? Where Are We Going?* (Boston, Museum of Fine Arts). In the middle, a Tahitian Eve plucks the fruit of knowledge from a tropical tree of paradise. The painting was done during a crisis that took the artist to the verge of suicide. No sign of such mental convulsions is yet visible in *Tahitian Landscape,* completed four years previously. The scene depicted in the horizontal format is bright with luminous, truly "paradisal" colors, the palette conveying the impression of the delicious, fresh, very first view of nature, as if through Adam's eyes. The landscape becomes the quintessence of purity and harmony. Still, an all too idyllic impression is avoided, signs of need and poverty not entirely eliminated. As the tiny figure of the man carrying two heavy bundles indicates, even in this apparently so timeless ambience, labor is necessary for survival.

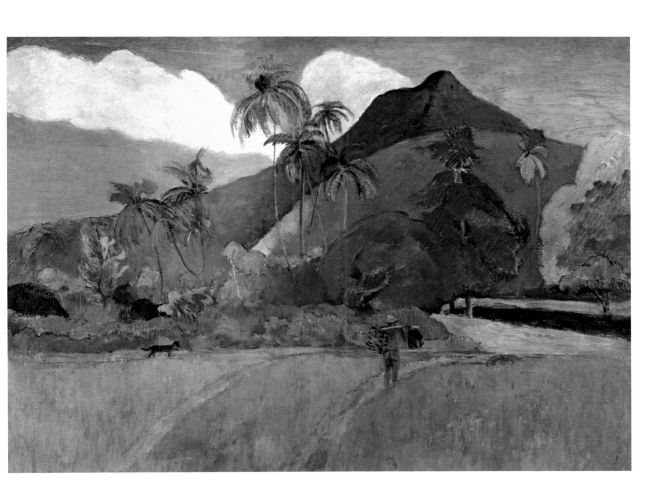

La montagne sainte-victoire

Oil on canvas, 60 x 72 cm
Basel, Kunstmuseum Basel

b. 1839 in Aix-en-Provence
d. 1906 in Aix-en-Provence

Cézanne's view of nature always entailed an observation of his own perception – nature and the resulting picture stood in a close, reciprocal relationship with one another. The artist expressed this in his famous definition of art as a harmony in parallel with nature. In his search for a new beginning in the wake of Impressionism, Cézanne had a crucial encounter with a mountain, the Sainte-Victoire in Provence, which, so to speak, became his new home. From the 1880s onwards he devoted about sixty oil paintings, drawings and watercolors to the subject. Eight of these paintings date from Cézanne's final years, after the turn of the century, including the one in the Kunstmuseum Basel, finished in 1904–1906.

If one were to describe the small painting in conventional terms, there would not be much to say. It has an almost continuous horizon line, set at about two-thirds of picture height, and resting on it, as if on a pedestal, the geologically characteristic formation of the Sainte-Victoire mountain, rendered in gradations of dark blue, in contrast to the green flecks covering the sky. Below the horizon extends a wide plain, dominated by the green of vegetation, then a few ocher-colored houses with red roofs, and the diagonal of a road or path. Despite the free treatment, the topography is clearly identifiable: the landscape is seen from the vantage point of the Plateau d'Entremont, a good kilometer north of Cézanne's studio on the Chemin des Lauves, with the mountain at a distance of about twenty kilometers as the crow flies. It is very much more complicated, however, to analyze the overall impression of the picture, its diverse yet so calm composition, void of framing elements or elements that would draw the eye into the picture. There is no foreground we could imagine walking into, yet nor is there any true distance, for the things in the picture do not grow smaller in accordance with their location in space.

The Sainte-Victoire is a monument of permanence not only as a motif, but also as part of a conception that diverges entirely from Impressionism, one that treats visual data not as signs of permanent change but as the sum of tiny building blocks, an order in which calm, stability, and motion are united.

The mountain and plain in themselves embody an equilibrium between rising and recumbancy, a harmonious interplay of vertical motion with horizontal stasis. The Basel painting is characterized by dark margins around a lighter center, which in turn grows more shadowy towards the middle. Out of this circling configuration the mountain rises like an individual thing, yet at the same time is integrated in the picture plane, which consists of a texture of dabs, or *taches,* of paint. These dabs are visible even from a normal viewing distance.

As we may gather from the harsh chrome green, bright blue, violet and heavy ocher, the artist is nowhere concerned with an illusion or imitation of nature. Instead, with the type and "artificiality" of his paint application, Cézanne decides in favor of form, sees color as form. Thus the color itself ultimately becomes a building block, what Gottfried Boehm describes as "part of that matrix out of which depicted nature takes shape." Nature appears as a model of a universal building plan; order is not simply given but first has to assume form.

> "The landscape reflects on itself, humanizes itself, thinks itself inside me. I objectify and fix it on my canvas… Maybe I'm talking nonsense, but it seems to me as if I am the subjective consciousness of this landscape, and my canvas its objective consciousness."
>
> **Paul Cézanne**

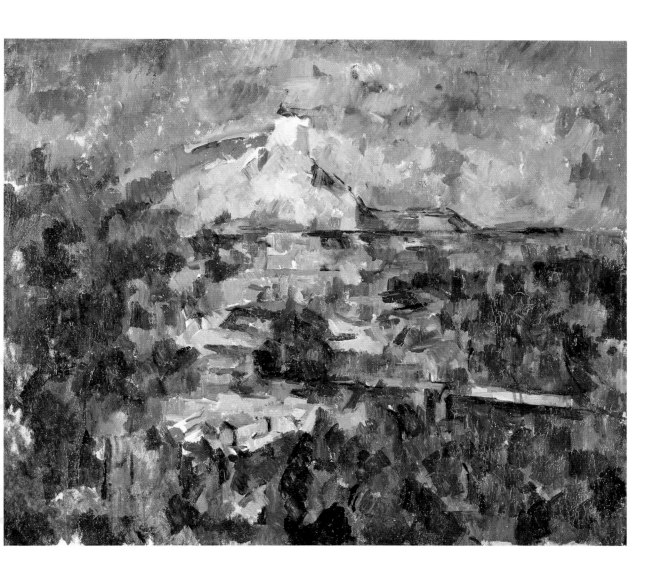

Landscape (The valley)

Oil on canvas, 81 x 65 cm
Basel, Kunstmuseum Basel, Gift of Raoul La Roche

b. 1882 in Argenteuil (Val-d'Oise)
d. 1963 in Paris

Among the artists with whom the collector Daniel-Henry Kahnweiler opened his famous gallery in Paris in spring 1907 was also Georges Braque. It was Kahnweiler again who introduced Braque to Picasso – a meeting that has been called the hour of birth of Cubism. That same year, Braque began to abandon the approach of Fauvism. While participating in the Salon d'Automne he marveled at a Cézanne retrospective, which confirmed him in his intention to consolidate forms on the picture plane. Spring 1908 consequently saw Braque's first Cubist works, which were probably not coincidentally devoted largely to the motif repertoire of landscape.

Since 1907 Braque had been staying in L'Estaque, a town on the coast near Marseille where Cézanne had also occasionally lived. The landscape compositions he produced there included the one illustrated, which is dominated by a nearly monochrome palette – primarily shades of gray with a few accents of green and ocher – and makes a virtually gloomy impression. However, this tonal range merely echoes certain earlier associations of subjective moods with the genre of landscape. Otherwise, the small painting is largely "objectified," that is, reduced to simple cubic or facetted configurations based on intrinsic laws. Nature, said Braque in words reminiscent of Cézanne's credo (ill. p. 79), must not be imitated, its appearances not be slavishly copied. Instead, the structural principles underlying appearances must be expressed in analogous formal structures.

Braque's *Landscape (The Valley)* was on view in the second exhibition of the New Artists Association in Munich, the group from which the southern German Expressionist group "Der Blaue Reiter" (The Blue Rider) would soon emerge. The idea of showing the Parisian Fauvists and Cubists in Munich surely went back to Wassily Kandinsky (1866–1944), a Russian artist active there at the time and one of the founders of "Der Blaue Reiter". While Braque's pre-Cubist and Cubist works – identifiable landscapes despite their abstracting tendencies – found a great resonance among many members of that group, Kandinsky, its most important representative, rapidly abandoned every objective reference and trod the path to pure abstraction. In this process too, landscape played a cardinal role as point of departure and catalyst.

Kandinsky's painting *Improvisation Gorge* marks a transition to the extent that rudiments of earlier landscape painting – indentifiable motifs such as ladders, a rowboat, a waterfall, and a pier with two figures – are integrated into the vortex of form and color, like quotes referring to the occasion of the painting, an excursion to an area near Garmisch-Partenkirchen known as the Höllentalklamm.

Wassily Kandinsky, Improvisation Gorge, 1914

kairuan, 1914, 42

Watercolor on paper and cardboard, 22.6 x 23.2 cm
Ulm, Ulmer Museum, Kurt Fried Collection Foundation

b. 1879 in Münchenbuchsee (near Bern)
d. 1940 in Muralto (near Locarno)

"Friday, 17th April. In the morning, painted again outside the town, close to the wall, on a hill of sand... Back through the dusty gardens outside town, painted a last watercolor, standing up." This is an entry from the diary Paul Klee kept during his journey to Tunisia. The aforementioned "last watercolor" records his farewell to Kairouan.

It has since become almost mythical, this two-week journey embarked upon in early April 1914 by two Swiss painters, Paul Klee and Louis Moilliet, and a German, August Macke, who for a time was a member of "Der Blaue Reiter" group in Munich. It was a trip that had great consequences, not only for the artists involved but for the entire history of modern art and the field of landscape in particular.

Their very first evening in Tunis fulfilled the three friends' expectation of being able to break through habitual ways of seeing in this exotic country with its new visual impressions. On the following days, outings in the vicinity of the Tunesian capital brought an unprecedented yield: "The most delicate definition of colors. Nothing painfully bright like at home... Green – yellow – terracotta." Kairouan and its environs became the high point of the journey, a source of visual stimuli Klee described in the following famous words: "Wonderful trip through an increasingly dessicated nature... Color has captured me. I don't need to try to catch any more. It has me forever, I know it. This is the meaning of the fortunate hour: I and color are one. I am a painter."

The watercolor of *Kairuan* (as Klee spelled it in his inscription) illustrated here reflects the artist's intention to depict space, time, and the mutual relationship of natural features by means of color chords, which in turn are integrated into a more or less geometric grid of small, tightly packed planes. The latter would soon develop into a definitely abstract configuration. Here, sparing line is still used to characterize details, and suggestions of perspective are still apparent in places. The astonishing trait of this watercolor and related ones consists in its effect of a subjectively perceived situation despite the high degree of abstraction which ultimately overwhelms every sign of traditional compositional means.

August Macke, too, found his way in North Africa to an intensity of color and light even greater than in his previous works. In addition to spontaneous sketches and drawings, he created thirty-eight watercolors in which his previous style came to full fruition. Composed along strict geometric lines, these works exhibit a seemingly insurpassable unity of color, light and space. Under the bright southern sun, Macke achieved his highest aim: to create images, landscapes, that drew their sustenance entirely from color – yet without ever fully crossing the borderline to abstraction.

August Macke, St. Germain near Tunis, 1914

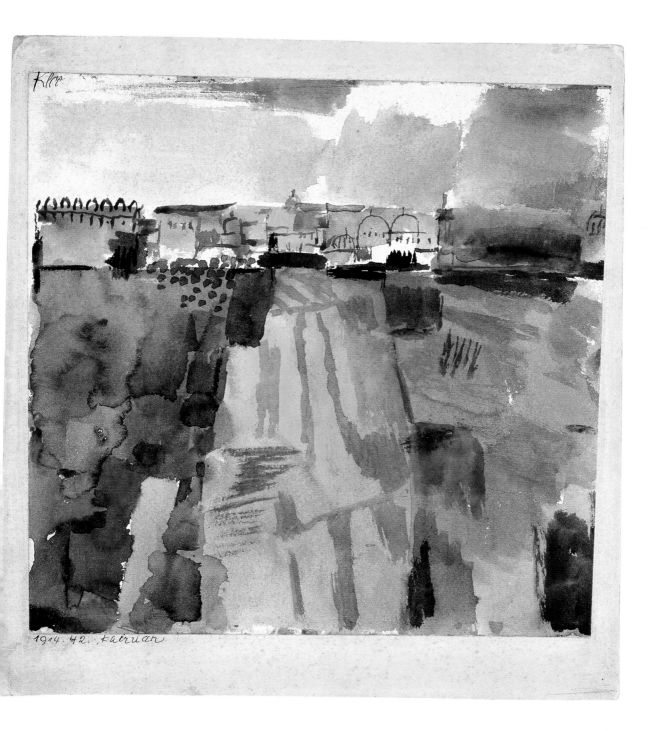

Klee

1914. 42. Kairuan

Tinzenhorn, zügenschlucht near monstein

Oil on canvas, 119 x 119 cm
Davos, Kirchner Museum Davos

b. 1880 in Aschaffenburg
d. 1938 in Frauenkirch (near Davos)

In 1905 Kirchner became a founding member of the northern German Expressionist group Die Brücke – and he was its most outstanding member. From the beginning landscape, alongside the nude, played a prominent role in these artists' work, before it made way for a focus on the big city in the years immediately preceding the First World War. After traumatic experiences in the army, Kirchner finally moved in 1918 to Switzerland, where landscape once again helped him to find himself. The oil paintings and woodcuts done from 1919 onwards represent outstanding apexes not only in Kirchner's oeuvre but in the context of European landscape painting as a whole. One of the finest is surely the mystical *Tinzenhorn, Zügenschlucht near Monstein*. "I dream of a Tinzen picture in the afterglow, just the mountain blue on blue, quite simple," noted Kirchner in his journal, a precise description of this truly visionary blend of darkly glowing color areas with large, simplified forms.

Just a short time previously in the grip of the nervous agitation that pervaded the cities on the brink of the war, in view of the Alps Kirchner was transformed into an astonished recorder of a profoundly emotional experience of nature. The overwhelming power of this impression went far beyond the effect of the Moritzburg Lakes and Fehmarn Island on the Brücke members in the group's early days.

An earthly paradise – the Expressionists, too, were involved in a quest for this ideal despite the apparent violence of their formal language – indeed with the aid of such "explosions" of form, which they viewed as equivalent to primitive, unadulterated force. Admittedly it was difficult to project the dream of a paradise lost, insofar as landscape was concerned, on an industrialized and thickly settled Europe. But there was an alternative.

In 1905, the same exotic world to which Paul Gauguin had fled began to attract the German Expressionist Emil Nolde (1867–1956). Yet this was no case of romantic escapism. Nolde pursued an artistic aim – to regain the "primal origin," the source of all human creativity. In 1913, he joined a scientific expedition to New Guinea. The works he executed on the island of New Ireland (then a German colony known as Neu Mecklenburg), included the fascinating *Tropical Sun*. Rising above the horizon line we see the dark green, forested silhouette of the neighboring island of Nusa Lik. This undulating shape projecting from the left into the composition is replied to by the white cumulus cloud above the horizon and the foaming breakers in the foreground. The incandescent red disk of the sun stands over the treetops, in the midst of a brilliant aureole surrounded by darker cloud formations.

Emil Nolde, Tropical Sun, 1914

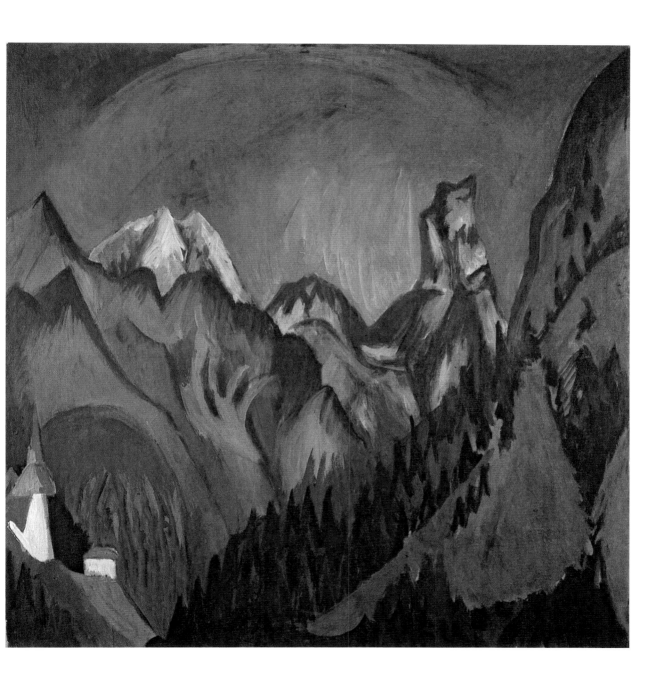

mountain Lake with swans

Oil on canvas, 65 x 75.5 cm
U.S.A., private collection

b. 1884 in Leipzig
d. 1950 in New York

Max Beckmann, called the greatest living German artist by the *New York Times* in 1946, was one of the creative geniuses of the twentieth century. Though Picasso may have surpassed him in terms of universality, in terms of an obsession to raise art to a myth of modernism they were equals. As art historians generally agree, this myth rested above all on Beckmann's triptychs, his fascinating self-portraits, and his figure paintings. His landscapes are relatively seldom included in this list. And yet of 835 Beckmann paintings, 190 are pure landscapes, not counting the cityscapes.

Basically, Beckmann's landscapes, or most of them, cannot be separated from his figurative compositions. In the tradition of German Romanticism, they are landscapes of mood and emotion, projections of human nature and states of mind onto the outside world. Often enough they possess a claustrophobic closeness, appearing to drastically reduce the human habitat in and around them. On the other hand, Beckmann often treated landscape as a symbol of freedom. This is why depictions of the sea became a favorite motif. His views through a window (another typically Romantic legacy) emphasized the contrast between the open sea under a far horizon and the "confined" viewer. This is apparent in *Scheveningen, Five O'Clock in the Morning* (Munich, Bayerische Staatsgemäldesammlungen, Pinakothek der Moderne), a slice of empty nature viewed in the early morning through a hotel window, where a wine glass on the sill signals the presence of the hotel guest and the incandescent red sunlight makes daybreak into an event witnessed by the invisible viewer's eye.

Not his beloved sea but a mysterious mountain lake in shimmering green figures in Beckmann's painting of 1936. He had spent that year and the previous one in Baden-Baden. Very probably this landscape, whose topography has yet to be identified, was one of a series painted in the nearby Black Forest.

The landscape has the extreme, well-nigh oppressively condensed atmosphere that was characteristic of Beckmann's compositions of the 1930s. The nearly black pines in the foreground rise like two threatening guards, as if protecting the precious lake – its oval surface glittering like an enigmatic, cold emerald – against human incursion. While the foreground space is blocked by trees, on the far shore of the lake and its rising terrain appear warm gradations of ocher that continue into the distance and merge with the horizon. Yet there, where expanse and calm prevail, a tense contrast is set by the windblown tops of the mighty pines. Their striking blackish-green hue evokes an end-of-the-world mood, like some natural memento mori. No wonder that the swans are seeking refuge in a hut on the shore.

With his explorations of the feelings and moods evoked by nature in the viewer's mind, Beckmann became one of the few truly great landscapists of the twentieth century.

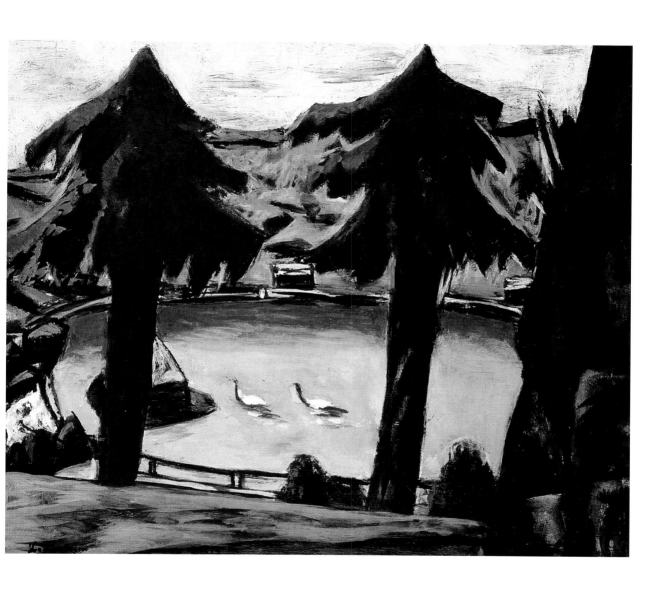

The Great Paranoiac

Oil on canvas, 62 x 62 cm
Rotterdam, Museum Boijmans van Beuningen

b. 1904 in Figueras (Figueres)
d. 1989 in Figueras (Figueres)

In 1933, the great Spanish Surrealist painted a striking landscape. However, as the title *The Phantom Cart* indicates, this is more than a purely natural scene. It shows a Catalan *tartane,* a two-wheeled covered wagon, rolling through the light-flooded, bare expanse of the Ampurdán plain, the region of Catalonia where Dalí was born. The town vaguely visible in the distance (possibly Gerona) is integrated in the gap in the open cover such that a church spire appears where we would expect to see the driver. The moving cart and its destination merge in the perspective depths, just as do the depicted reality and a fiction rendered with hallucinatory precision. Contemporary observers admired *The Phantom Cart* for the way it captured the character of the desert-like terrain better than any other Dalí picture. Yet this naturalism takes on a nightmarish aspect as soon as one discovers that the church spire visible through the cart's open cover becomes a protagonist in its own right. Still, the naturalistic landscape and its metamorphosis have one thing in common – the mood evoked by the dessicated plain and a yearning for the distant destination that promises rest and succor.

Three years later, Dalí completed an Old Masterly painting that brought the contrast between detailed realism, mannered figuration and phantasmagoria to a peak. Moreover, the painting demonstrated that rather than treating landscape as an end in itself, Dalí used it as a site of metamorphoses in which naturalism was alienated to the point of hallucination. This was *The Great Paranoiac.* In view of this picture, one is reminded of that passage in the artist's journal, *The Secret Life of Salvador Dalí,* where he describes a moment that triggered his imagination, much as did Leonardo da Vinci centuries earlier, providing a "genetic" explanation for the imaginative richness contained in fictitious landscapes. Dalí described how, during boring hours in school, he used to gaze at the classroom ceiling, whose great brown water stains turned in his imagination into clouds, then into concrete images that gradually took on a very precise meaning. The next day he took up these images, reconstructed them, and developed the hallucinations further.

The imaginative force of this virtuoso tone-in-tone composition spirits the viewer into Dante's *Inferno,* where lost souls wander aimlessly or resign themselves to their fate. The sole meaning in their lives seems to consist in a transformation of their bodies, as in a trance or anamorphotic game, into human skulls and melancholy masks.

The analogies of the ghostly figures in *The Great Paranoiac* to those of the manneristic Italian late Baroque painter Alessandro Magnasco (1667–1749) extend to the treatment of the landscape surroundings as well. With the aid of such means, Dalí transforms a natural-seeming wilderness like that seen in *The Phantom Cart* into an endless "hell on earth."

The Phantom Cart, 1933

Day of Indolence

Oil on canvas, 92 x 73 cm
Paris, Musée National d'Art Moderne, Centre Georges Pompidou

b. 1900 in Paris
d. 1955 in Woodbury (Conn.)

In Surrealism, landscape conquered a new dimension, passing through one of the strangest metamorphoses in the history of the field. The Surrealist landscape can best be understood against the background of the new image of nature reflected in modern art as a whole. Put simply, artists' image of nature became blurred, in terms of both form and content, but made up for this loss of clarity by establishing a new, aesthetic totality. Nature no longer needed to be presented to the eye in the form of a composed, atmospheric landscape. Rather, it could find its place entirely in us as viewers, in our psyche and dreams.

One of the continually recurring Surrealist scenes is a landscape of desert plains populated by strange objects, anthropomorphic, vegetable, or crystalline configurations, metamorphoses or hybrids of human beings and things, objects existing in airless spaces full of strange perspectives and under a cold, extraterrestrial sky. Especially the French artist Yves Tanguy made a name for himself with such dreamlike vistas from 1926 onwards. The way his horizons with their milky, misty bands cut uninterruptedly through the picture evokes an endless planet, whose banded structures bring natural terrain to mind. But these memories can be no more than vague, due not only to the bizarre utensils and phantasmagorical figures but to the indefinite time of day, season, and spatial relationships.

In *Day of Indolence,* Tanguy projects scenery whose eerie, visionary character is heightened by the way in which the figurative elements, rendered with sharp-edged precision, stand out against a ground divided into zones that calls to mind an infinite expanse of desert. In addition, the surreal configurations cast threatening black shadows, suggesting a space that by all rights cannot exist in this alogical world.

Familiar definitions of time and space are invalidated by a faceless landscape in which the aesthetic qualities of landscape seem lost in a void resulting from some apocalyptic disaster. From a high vantage point like that of a universal landscape, our eye surveys this forbidding terrain, illuminated by a threatening cosmic light.

In Tanguy's "landscapes" we overlook a world whose Surrealist perspective cannot be read as a physically rational structure, because it is much too enigmatically encoded. Nor does the high vantage point give us a feeling of mastery, because there is nothing there to be mastered. The landscape draws our eye into it, only to confront it with ciphers that shift the question of the meaning of human life and the world into the realm of the psyche. Its vague memories of visual realities mark this process as a borderline exchange, where dream elements are smuggled with hallucinatory precision into reality and fragments of reality are incorporated in dream.

> **"But with Tanguy, it will be a new horizon, one in front of which the no longer physical landscape will spread out."**
> **André Breton**

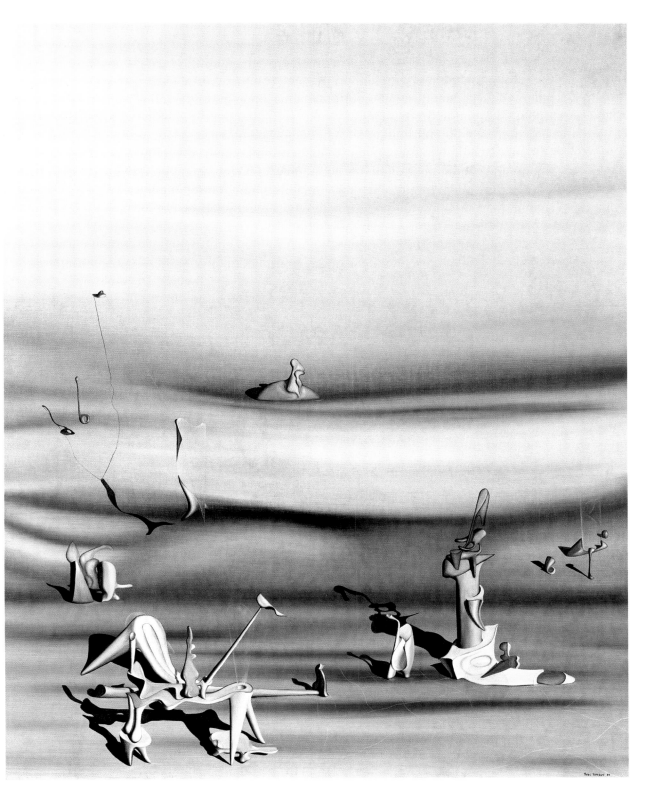

DO It Yourself (Landscape)

Acrylic on canvas, 178 x 137 cm
Cologne, Museum Ludwig

b. 1928 (?) in Forest City (Penn.)
d. 1987 in New York City

As its ironic title indicates, Warhol's painting paraphrases the painting-by-numbers sets advertised in countless department store catalogues, promising that amateurs can become real artists simply by filling out the numbered fields with the "right" colors.

In keeping with the basic thrust of Pop Art, Warhol illuminated the function of mass-produced imagery in the everyday life of industrialized society. In the process he not only continued the invective begun by Dada against the bourgeois aspects of art by persiflaging popular subjects like charming farm scenes. Beyond this, he destroyed everything that previously constituted the artistic task of landscape painting. He deprived it of all symbolic character of the kind which Gauguin so demonstratively embodied in his exotic paradises, for example in *Tahitian Landscape* (ill. p. 77). And he eliminated every underlying subjective attitude. Warhol always advocated a radical waiver of emotional engagement, an attitude which could be taken ad absurdum, as seen in *Do It Yourself*. In this 1962 work, the shaping force of subjectivity was reversed to produce a collective template. Landscape, which Max J. Friedländer could still describe as the "face of the land, the land in its effect on us" (see p. 7f.), has been rendered faceless, our shaping emotions in view of it eliminated.

Another Pop great, Roy Lichtenstein (1923–1997), concerned himself with strategies of "disenchantment" in a different if comparable way. He, too, did not spare the theme of landscape, as seen in his 1980 painting *Landscape with Figures and Rainbow*. On the one hand, the composition maintains a fine balance between objectivity and abstraction – trees, a tree stump, hilly terrain, human figures at the right, but also geometric areas and mechanical hatching. Although the landscape and the ancient, once so meaning-charged symbol of the rainbow (see *Heroic Landscape with Rainbow* by Joseph Anton Koch, p. 55) remain recognizable, they nevertheless tend to merge into an abstract, decorative pattern. Ultimately *Landscape with Figures and Rainbow* amounts to a reflection on art in art.

On the other hand, Lichtenstein focuses on "the typical," standardized imagery he unmasks as clichés of visual semantics. Landscape, he seems to say, is nothing but an empty shell into which expectations and romance that have nothing to do with reality are projected. The emotion and passion once so closely associated with landscape collide with the detachment of a cool, mechanically standardized rendering. Yet by means of this very impersonality, Lichtenstein manages to raise the banality of mass culture to a universal level. He may deprive the viewer of every opportunity for aesthetic pleasure in landscape, but not of the opportunity for intellectual reflection.

Roy Lichtenstein, Landscape with Figures and Rainbow, 1980

DAVID HOCKNEY

nichols canyon

Acrylic on canvas, 213.3 x 152.4 cm
Private collection

===

b. 1937 in Bradford, West Yorkshire, Great Britain

The artist himself has described the origin of this very large and ebulliently colored painting. Because he did not know many people in Hollwood Hills, Hockney recalled, he didn't go driving up there, because it was quite easy to get lost. But after he had moved there, he began to see Los Angeles from a different viewpoint. The winding roads began to pervade his life, and then his art. Hockney began *Nichols Canyon,* selecting a big canvas and painting a snaky line in the middle, just as the road appeared to him. He lived in the hills and worked in his studio downtown, commuting back and forth, sometimes two, three, even four times a day. He began to sense that the sinuous lines of the road had literally got into his bloodstream.

Born in England, Hockney developed an idiom in painting, drawing and printmaking that is related to Pop Art without being truly equivalent to it. After an initial phase of symbolic abbreviation of the banal, everyday world, in the 1970s he turned increasingly to a more naturalistic approach. This is seen in *Nichols Canyon,* which surprisingly has an almost traditional look that distantly recalls Fauvist landscapes but also those of the early Paul Klee, in the way it oscillates between stylization and realistic depiction, but especially as regards its brilliant palette.

In his own description of the painting, Hockney emphasizes the element of the road running past his house and its sinuosity. The winding road indeed holds the place of prominence along the central axis of the vertical format, as it were snaking around this virtual vector. At the same time, the black band – or better, narrow track – opens up the image in the direction of depth, if not in the sense of strict one-point perspective. As Hockney once explained in another context, the vanishing-point perspective of the Renaissance – which struck people in the fifteenth and sixteenth century as a realism that could not be surpassed – increasingly lost its magic from the nineteenth century onwards, as discerning people realized that space could be depicted in a different way.

While the road winding into the distance in *Nichols Canyon* suggests the perspective illusion of space that determined Western painting for centuries, it is flanked by a number of changing scenes viewed from above that appear to tip forward into the picture plane, recalling the bird's-eye panoramas of earlier universal landscapes. Ultimately Hockney's composition is not a coherent landscape but an addition of visual impressions gained from driving along the road, the resulting continual change of viewpoint, and a superimposition and juxtaposition of these different perceptions.

In a related landscape painted that same year, *Mulholland Drive,* Hockney heightened the drama of the events he had depicted with a certain aesthetic pleasure in *Nichols Canyon.* When you look at *Mulholland Drive,* the artist explained – and by "drive" he did not mean the name of the road but the act of driving – your eye moves along the road at the same speed as a car.

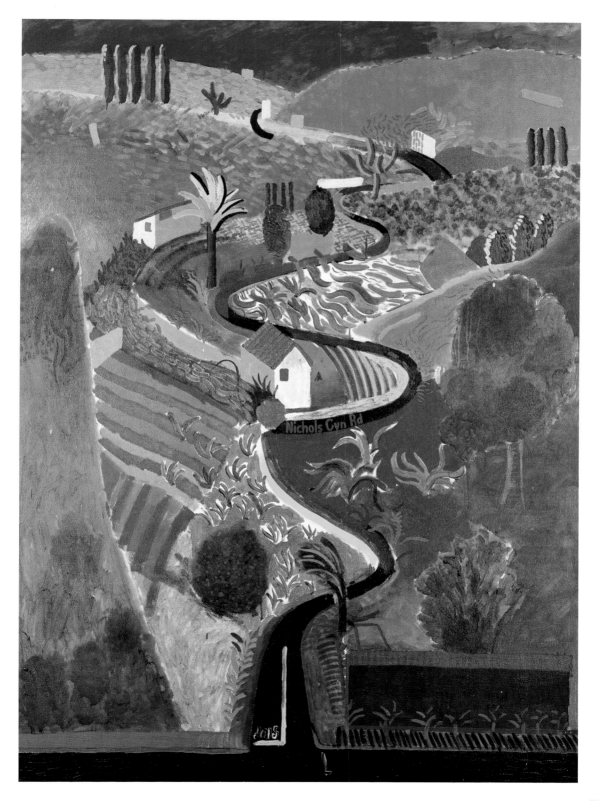

To stay informed about upcoming TASCHEN titles, please request our magazine at www.taschen.com/magazine or write to TASCHEN America, 6671 Sunset Boulevard, Suite 1508, USA-Los Angeles, CA 90028, contact-us@taschen.com, Fax: +1-323-463.4442. We will be happy to send you a free copy of our magazine which is filled with information about all of our books.

© 2008 TASCHEN GmbH
Hohenzollernring 53, D−50672 Köln
www.taschen.com

Project management : Ute Kieseyer, Cologne
Editing: Werkstatt München · Buchproduktion, Munich
Translation: John William Gabriel, Worpswede
Layout: Anja Dengler for Werkstatt München, Munich
Production: Tina Ciborowius, Cologne
Design: Sense/Net, Andy Disl and Birgit Reber, Cologne

Printed in Germany
ISBN: 978-3-8228-5466-2

Reference illustrations:
p. 26: Limbourg Brothers, *The Month of May*, fol. 5v of *"Très Riches Heures,"* c. 1410−1416. Tempera on parchment, 29.4 x 21.5 cm (sheet). Chantilly, Musée Condé, ms. 65
p. 34: Hieronymus Bosch, *The Creation* (?), triptych exterior of "The Garden of Earthly Delights," 1480−1490. Oil on wood, 220 x 390 cm. Madrid, Museo Nacional del Prado
p. 42: Lucas van Valckenborch, *Maas Landscape with Mine and Smelting Sheds*, 1580. Oil on oak, 76.5 x 107.5 cm. Vienna, Kunsthistorisches Museum Wien
p. 44 bottom: Rembrandt Harmensz. van Rijn, *The Rest on the Flight into Egypt*, 1647. Oil on wood, 34 x 48 cm. Dublin, The National Gallery of Ireland
p. 50 bottom: Claude Gellée, known as Lorrain, *Seaport at Sunrise*, 1674. Oil on canvas, 72 x 96 cm. Munich, Bayerische Staatsgemäldesammlungen, Alte Pinakothek
p. 52 bottom: Jacob van Ruisdael, *View of the Bleaching Fields outside Haarlem*, c. 1670−1675. Oil on canvas, 55.5 x 62 cm. The Hague, Mauritshuis
p. 56 bottom: Carl Gustav Carus, *The Goethe Monument*, 1832. Oil on canvas, 71.5 x 53.5 cm. Hamburg, Hamburger Kunsthalle
p. 60 bottom: Adolph von Menzel, *The Berlin-Potsdam Railway*, 1847. Oil on canvas, 43 x 52 cm. Berlin, Staatliche Museen zu Berlin − Stiftung Preussischer Kulturbesitz, Gemäldegalerie
p. 64 bottom: Frederic Edwin Church, *Niagara Falls*, 1857. Oil on canvas, 108 x 229.9 cm. Washington, D.C., The Corcoran Gallery of Art
p. 66 bottom: Jean-Baptiste Camille Corot, *Morning, Dance of the Nymphs*, 1850. Oil on canvas, 98 x 131 cm. Paris, Musée d'Orsay
p. 70 bottom: Fabrizio Clerici, *The Presences*, 1974. Oil on wood, 120 x 120 cm. Bologna, Galleria Forni Collection
p. 74 bottom: Georges Seurat, *"Le Bec du Hoc," Grandcamp*, 1885. Oil on canvas, 64.8 x 81.6 cm. London, The Tate Gallery
p. 80 bottom: Wassily Kandinsky, *Improvisation Gorge*, 1914. Oil on canvas, 110 x 110 cm. Munich, Städtische Galerie im Lenbachhaus
p. 82 bottom: August Macke, *St. Germain near Tunis*, 1914. Watercolor, 26 x 21 cm. Munich, Städtische Galerie im Lenbachhaus
p. 84 bottom: Emil Nolde, *Tropical Sun*, 1914. Oil on canvas, 71 x 104.5 cm. Seebüll, Nolde Stiftung Seebüll
p. 88 bottom: Salvador Dalí, *The Phantom Cart*, 1933. Oil on wood, 16 x 20.3 cm. Private collection
p. 92 bottom: Roy Lichtenstein, *Landscape with Figures and Rainbow*, 1980. Oil and Magna on canvas, 213.4 x 304.9 cm. Cologne, Museum Ludwig

Page 1
CASPAR DAVID FRIEDRICH

Evening on the Baltic Sea
c. 1830−1835, oil on canvas,
25 x 31 cm
St. Petersburg, The State Hermitage

Page 2
VINCENT VAN GOGH

Road with Cypress and Star
1890, oil on canvas,
92 x 73 cm
Otterlo, Kröller-Müller Museum

Page 4
ALBRECHT ALTDORFER

Danube Landscape with Wörth Castle near Regensburg
shortly after 1520, gouache on parchment on wood, 30.5 x 22.2 cm
Munich, Bayerische Staatsgemäldesammlungen, Alte Pinakothek